# SUSSEX
## THROUGH TIME
Douglas d'Enno

BRADWELL
BOOKS

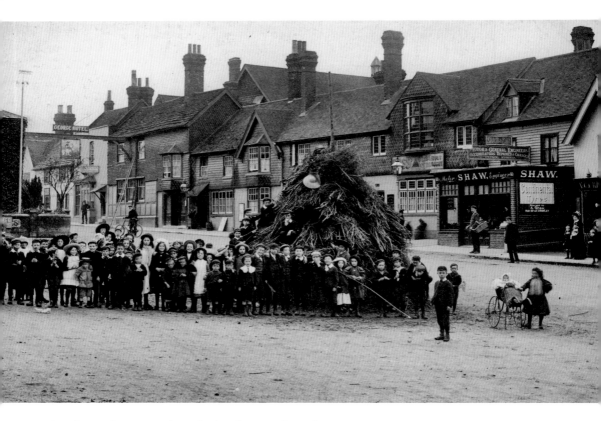

Crawley High Street, where the bonfire stands ready.

First published in 2013 by
Amberley Publishing for Bradwell Books

Amberley Publishing
The Hill, Stroud, Gloucestershire, GL5 4EP
www.amberley-books.com

Copyright © Douglas d'Enno, 2013

The right of Douglas d'Enno to be identified as the
Author of this work has been asserted in accordance with
the Copyrights, Designs and Patents Act 1988.

ISBN  978 1 4456 0900 3

British Library Cataloguing in Publication Data.
A catalogue record for this book is available from the
British Library.

Typesetting by Amberley Publishing.
Printed in Great Britain.

# Introduction

This volume is intended as a companion to my *Sussex Coast Through Time*, published by Amberley in 2012. The success of that book revealed the level of interest among the reading public in the heritage and attractions of this remarkable county. Despite the present publication focusing primarily on inland towns and villages, the larger coastal communities could not be ignored. In such cases, the early images selected depict scenes other than beaches or shorelines and portray town centres.

Although not perhaps apparent, a scheme has been used to arrange the entries in order by District as follows – in East Sussex: Rother, Wealden and Lewes (Hastings and Eastbourne are separate Boroughs whilst Brighton and Hove is an independent unitary authority); and in West Sussex: Mid Sussex, Crawley (Borough), Horsham, Adur, Worthing (Borough), Arun and Chichester.

While the whole of Sussex is represented, from South Harting in the west to Rye in the east, it would have been impossible to include every settlement in the county. The images used, which dictated the content, are the very best that could be acquired, sometimes with difficulty and often at great expense, and date predominantly from the period 1905–25.

A recurring theme in my descriptions of the early pictures is any local rail connection; this has in many cases been lost, but the map on page 96 does show the extent of the network in Sussex in 1904 and will doubtless be of intrinsic interest to readers.

Photographers in the early twentieth century had the benefit of virtually traffic-free roads from which to take their pictures. Replicating an image today has often been a hazardous undertaking, but it had to be done. Also, the vehicles needed to be shown in order to reflect reality.

As was the case when preparing the coastal book, the right local person so often appeared at the right moment. Yet this could not be relied on, so I made it my duty to call on every property surviving from the early images to find out about it. Some residents and traders knew more than others about where they lived and worked respectively but what struck me most was the hospitality and friendliness shown and the interest expressed in the project.

Space does not allow me to name the publishers of the old pictures used – almost invariably postcards – but some have been referred to in the text. Many local photographers chose to remain anonymous. Nationally known, local or unnamed, I salute them all.

Acknowledgements by locality are set out overleaf but here I should like to thank my wife Caroline for her patience in the face of many forfeited family weekends, and to express my appreciation to the production team at Amberley Publishing for creating such an attractive volume.

Douglas d'Enno
Saltdean, 2013

# Acknowledgements

These are arranged in alphabetical order by locality, preceded by the names (in alphabetical order by surname) of those persons who kindly assisted in the preparation of this volume. For reasons of space, it has not been possible to include any details of affiliation to any particular body or organisation next to those names.

Should anyone have been inadvertently omitted, I offer him/her my sincerest apologies.

Neil Rogers-Davis (Angmering), Clive Izard (Ardingly), Julie Budgen, Paul & Isabella Gordon (Balcombe), Ian Hilder, Margaret Turner (Barcombe), Julian Porter (Bexhill-on-Sea), Martin & Margaret Burgess (Bolney), Pamela Gainer, Simon & Sara Parker (Boreham Street), Peter Bernon, Beeding & Bramber Local History Society (Bramber), Catriona Clark (Brighton), Ivan Ball (Burgess Hill), Frances Archer, Oliver Blaydon, Ken & Jo Hart (Burwash), Keith Ambridge, Helen Poole (Crawley), Gareth Hockin (Crowborough), Mike Davom (Dallington), Judith Davies (Ditchling), Barry Handley, Paul Nash (East Dean), Shaun Adams (East Preston), Eastbourne Reference Library (Eastbourne), Valerie Martin (Findon), Celia Bishop, Kelly Clark, Lisa Hale (Flimwell), Pam Allsop, Ann Turner (Framfield), Andrew Lusted (Glynde), Roger Mozley, Mary Butterworth, James Wood (Graffham), Alan Hibbs (Hailsham), Lily & Joe Elliott, John Wenham (Halland), Mike Parcell (Hartfield), Dianne Jones, Frederic Avery (Hassocks), Jane Dore, Martin Hayes, Haywards Heath Library, Colin Manton (Haywards Heath), Alan Barwick (Henfield), Rupert Chandler, Andrew Hair, Rebecca Hair (Hurstpierpoint), Mark Welch (Lancing), Richard Bryant (Lindfield), Mark Betts, Julian Porter (Little Common), Juliet Nye (Littlehampton), John Bennet, Clive Brooks, Stephanie Mack, Irene Surman, John Wrake (Maresfield), Rob Foster, Ray Hamilton (Mayfield), Mary Geiss, Brigid Howard, Ginny Kempster (Midhurst), Peter Bailey, Christopher Wrapson (Newhaven), Margaret Catt, Janine & Graham Sterling (Northiam), Susan Rowland (Offham), Bob Dunn (Pevensey Bay), Penny Barnes, Peter Tyrrell (Polegate), Carolyn Burley, Sue MacMahon, Timothy Martin (Pulborough), John Stamper (Ringmer), Brian Hill (Ripe), David Claydon, Penny Rankine-Parsons, Anne Stevens (Robertsbridge), James Stock (Rogate), Les Barnett, Malcolm & Kim Keen, Tony Livings (Scaynes Hill), Mike Wright (Seaford), Trevor Povey (Shoreham), Ann Pollock (Singleton), Philip Berry, Jane Cecil (Slindon), Caroline Fredericks, Nigel & Cathy Johnson-Hill, John Owen Smith (South Harting), Trevor Povey, Mike Wilkinson (Southwick), Chris Tod (Steyning), Audrey Jesty, Storrington Museum (Storrington), Wayne Lowrie (Tarring), Jhonnie De Oliveira, James & Zoe Groves, Marion Prior, Angela Vinson (Ticehurst), Eric Dawes, Shobhana Keshavji (Turners Hill), Martine Laine (Uckfield), Beeding & Bramber Local History Society (Upper Beeding), Avtar Bansel, Richard Hardy Smith (Wadhurst), Pat Greenaway, Ann Salmon (West Chiltington), Dr Pauline Hands, Dr John Ralph (West Hoathly), Paul Lewis (Westham), Steve Comber, Richard Comotto (Winchelsea), Worthing Local Studies Library (Worthing).

Numerous books and websites have, of course, been referred to in preparing the book but, for reasons of space, a listing has had to be omitted.

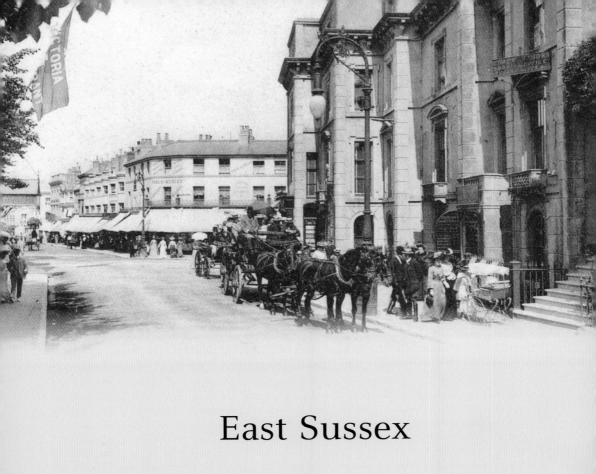

# East Sussex

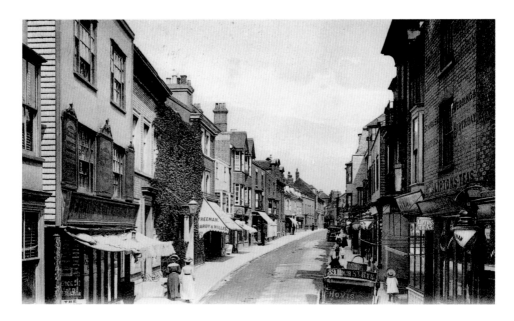

## Rye, High Street

Founded in the eleventh century, the port and market town of Rye was built on a former island hilltop. This richly historical settlement, a magnet for tourists, lies about 2 miles from the open sea, at the confluence of three rivers. The High Street, decorated below for the Queen's Diamond Jubilee in 2012, boasts a wide variety of buildings, many unchanged for decades or even centuries, with the earliest dating back to around 1400. Today's Corner House (No. 27) was, between around 1890 and 1920, the office building of Reeve & Finn, auctioneers. Between March and June 1943, when empty, it was taken over for the fundraising campaign of Rye Wings for Victory Week. The box-like building next door (No. 26), today's Martello Bookshop, formerly housed Deacon's Steam Printing Works, which published the *South Eastern Advertiser*, his 'Depot for Rye Rustic Art Pottery' and his lending library.

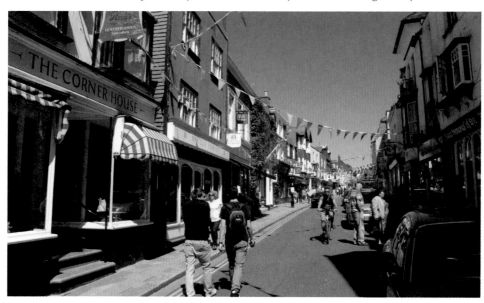

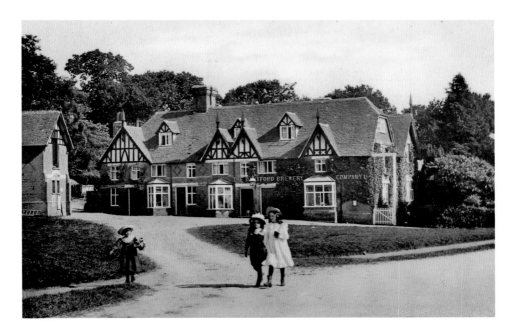

### Northiam's Lost Hotel

A charming village in the valley of the River Rother and lying on the A28, which links Canterbury and Hastings, Northiam is located 13 miles north of the latter resort. Prominent among its historic buildings are Frewen College, centred on a Grade I listed Jacobean mansion named Brickwall, and the Tudor house Great Dixter, noted for its splendid gardens. St Mary's church dates from 1090 and its six bells are commemorated in the name of the former hotel in the above view. This was tastefully converted into four substantial residences in 1993. The building on the left, now obscured, is part of the former Coach House, restored for residential use in the 1980s. The magnificent oak on the Green was planted in 1911 to commemorate George V's Coronation.

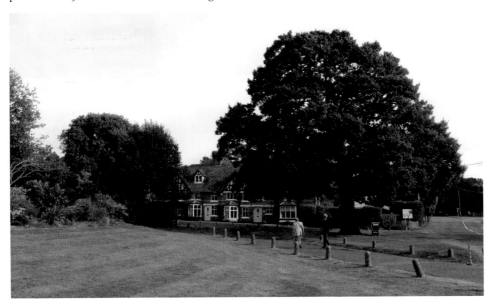

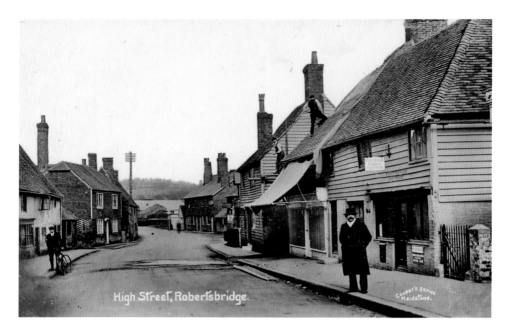

High Street, Robertsbridge.

### Robertsbridge, High Street

Traversed by the River Rother, this picturesque village, approximately 10 miles north of Hastings and 13 miles south-east of Tunbridge Wells, has suffered quite severe flooding over the years but now has secure defences in place. A plaque on the (nearest) property on the right, No. 22 High Street, tells us that it served from 1840 to 2008 as Robertsbridge post office. Its postmaster from at least 1891 to 1924 was Charles Butcher. The present owner of the premises operates a post office-cum-travel agency across the street. No. 20 next door – today's Floral Boutique Ltd – is run by Mrs Anne Stevens, seen below outside her shop. At the time of our early view (1910), it was in the hands of Michael Siviers, chimney sweep and cycle agent. The two properties are understood to date from 1610. Next on the right are Nos 16 and 18, built as a single dwelling in 1560 but divided in the 1700s.

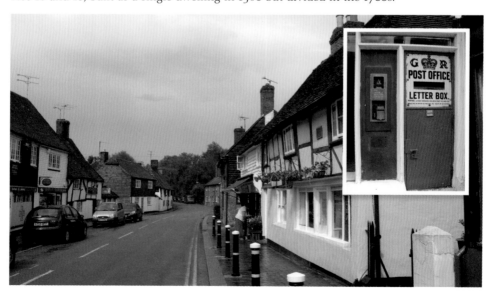

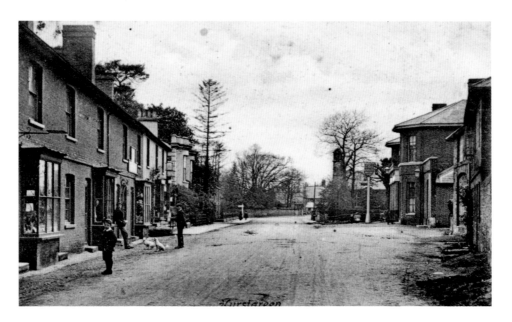

## Hurst Green, London Road

Obtaining a present-day view of this scene is a distinctly hazardous undertaking, since this stretch of the A21 Hastings to Lewisham road is normally heavy with traffic. Further on in the village, the road meets the A265 from Heathfield. The London Road contains many listed buildings; among them, on the immediate right, is Sandstones, the (extended) former stables of the Royal George public house, whose bays may be seen a little further on. Both date from the early nineteenth century. Today, the Royal George houses the award-winning Malaysian/Chinese cuisine restaurant Eurasia. Over the road stands the distinctive late Georgian property Little Bernhurst, behind which is the early Georgian Bernhurst. Partly concealed by a tree in the distance in the early postcard is the clock tower, erected by public subscription in memory of one George Burrow Gregory (Conservative MP between 1868 and 1874) of Boarzell, who died on 5 March 1892.

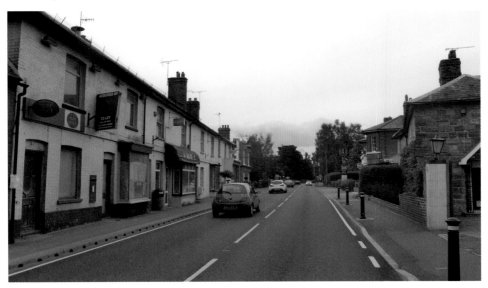

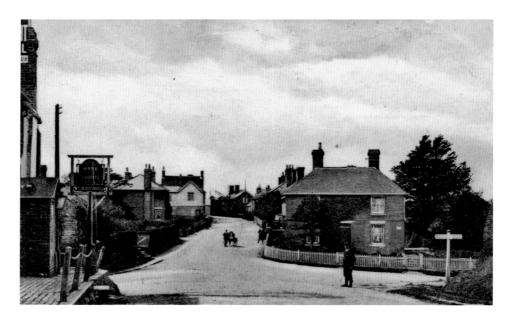

### Flimwell, The Street/High Street

Flimwell is a stone's throw from Kent. At this crossroads, realigned in 1931, the A21 London to Hastings road is met by the Hawkhurst Road (A268), from where the pictures were taken, and the B2087 to Ticehurst, 2 miles distant along the High Street facing us. The street contains a pleasing mix of old and new cottages and other dwellings. On the left is gabled Lodgefield Cottage, dating from 1814. Formerly Fairview, it was a butcher's premises between the wars. In front of it (nearer the camera) are the two semi-detached properties that make up Fern Villas. On the corner opposite (behind the right-hand traffic light) the former single property is now divided into Corner House (No. 1 High Street) and Corner Cottage (No. 2 London Road). On the extreme left, the Hare and Hounds Inn traded until some twenty years ago, when the premises were acquired by Country Furniture Barns Ltd.

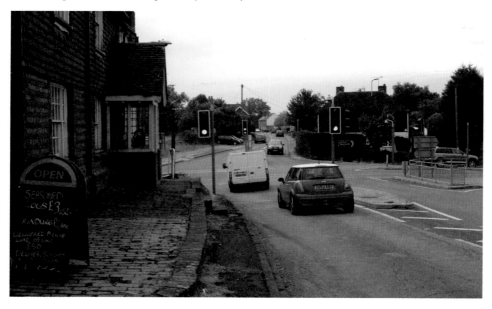

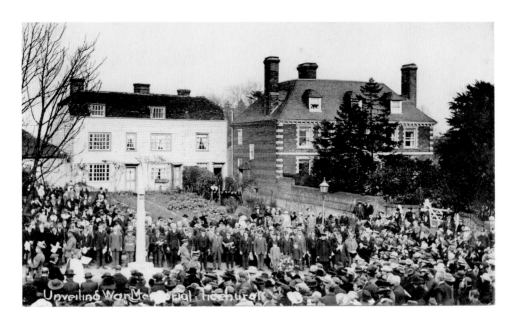

## Ticehurst, High Street

'Lest We Forget Our Glorious Dead' is the First World War inscription at the base of the village's war memorial, unveiled on 27 February 1921. It stands beside the main road under a large chestnut tree. The village church of St Mary records the names of sixty-two local men who made the ultimate sacrifice. In the background are the eighteenth-century Bell Cottages; between them and the Bell Inn, whose historic core dates from the sixteenth century, stood the stables and coach houses. When these were demolished, the ground was grassed over then turned into a car park for the inn. On the right is Apsley Court, now converted into flats; formerly known as Steellands, it is a late seventeenth-century building refronted in the nineteenth century. This attractive village, like Wadhurst (nearly 4 miles distant) and Flimwell (about 2 miles away), lies along a ridge in the heart of the High Weald Area of Outstanding Natural Beauty.

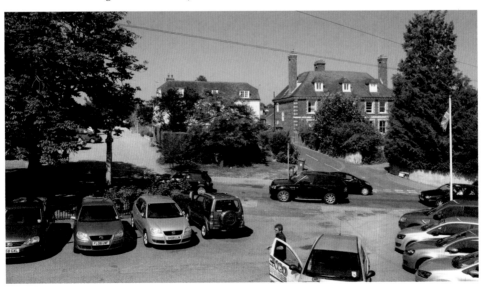

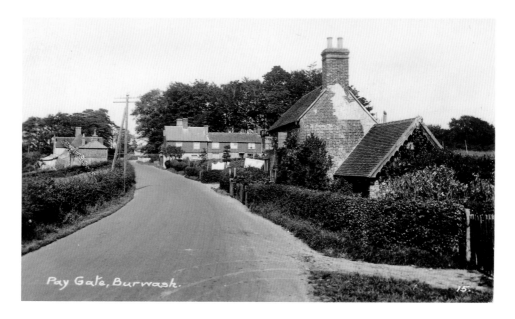

Pay Gate, Burwash.

**Burwash, Heathfield Road**

Burwash lies some 6 miles east of Heathfield and roughly midway between Tunbridge Wells to the north and Hastings to the south. Located 8 miles from Senlac Field, it marks the northern boundary of '1066 Country'. It is served by rail at Etchingham, 3 miles to the east. This popular view from the south-west features Kim's Cottage, nearest right, which echoes in its name the title of one of the works by Rudyard Kipling; his home from 1902 until his death in 1936 (Batemans) is reached half a mile away along Bateman's Lane, just behind the photographer. The listed cottage, a seventeenth-century or earlier timber-framed building refaced in the eighteenth century with brick, now painted, was run as a tea rooms in the 1950s. The row of cottages in the distance was formerly known as Millward Cottages.

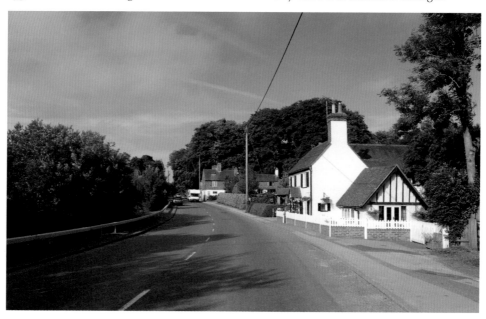

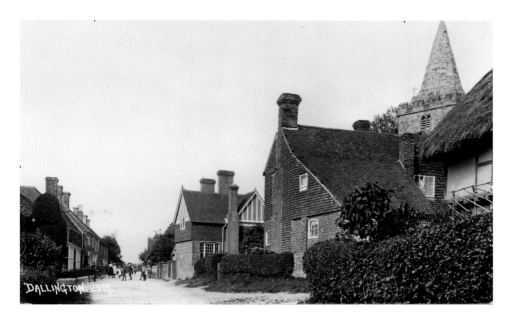

## Dallington, The Street

There are no fewer than fifty listed properties in this charming village, located 8 miles west of Battle and 5 miles east of Hailsham. The Old Manor House on the extreme right is a late fourteenth- or fifteenth-century hall house, while the predecessor of Old Church Cottage in front of the tower predates the close of the seventeenth century. Rebuilding took place in the early eighteenth century, and since then there have been various extensions and alterations. The village church of St Giles is thought to have been originally (until 1643) dedicated to St Margaret. It was pulled down and replaced in 1864, with the exception of the tower and steeple (undergoing repair at the time of my visit and previously in 1930).

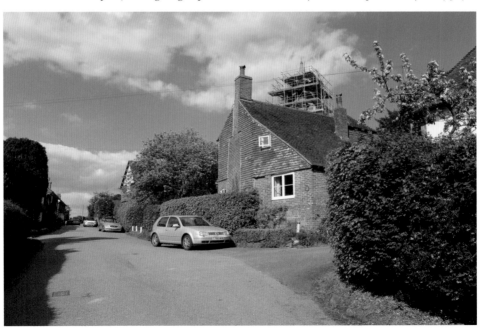

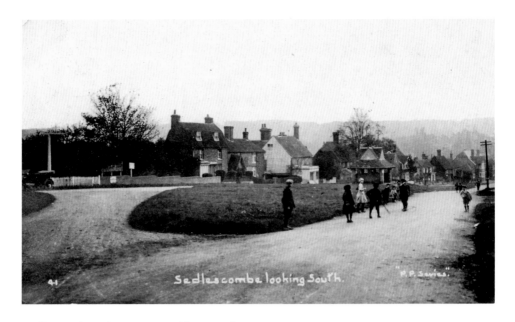

### Sedlescombe, The Green Looking South

The best gunpowder in Europe was once made at this hillside village, located about 6 miles north of Hastings and about 4 miles north-east of Battle. An information board on the wall of the fourteenth-century Queen's Head public house close to the famous Green commemorates 100 years of progress in the village in general and of the existence of the parish council in particular (1894–1994). A roundel on the building tells us that Sedlescombe lies on the Smugglers' Trail, officially launched on 26 May 2011, between Goudhurst and the coast via Hawkhurst – home of the notorious gang of that name. Dating from 1900, the Pump House seen here was provided by Samuel Bucknill in memory of his mother and two aunts. Its roof was repaired in 2001 at a cost of £6,200.

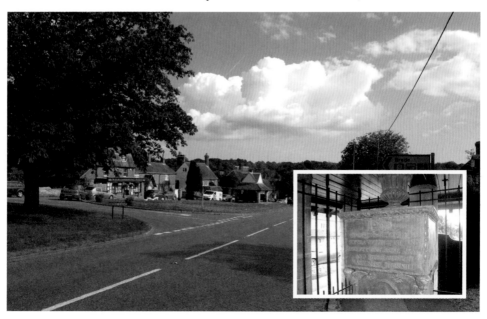

## Battle, High Street

Located at the heart of the Sussex Weald, Battle is the site of the Battle of Hastings, where William, Duke of Normandy, defeated King Harold II to become William I in 1066. The date is today commemorated in the hotel of that name, which in 1855 was named the Star Commercial Inn and, by 1891, the Star Hotel. The twin tall properties on the right were built ('in the worst possible taste' according to Aylwin Guilmant in her book *Bygone Battle*) between 1898 and 1902, replacing interesting old shops. Partly in view on the far right in today's image only is Battle Memorial Halls, an events centre. The premises were originally a sixteenth-century dwelling known from the 1730s as Langton House. A few years earlier, and again in the early nineteenth century, it was briefly a poorhouse. It then reverted to family occupation until taken over for public use in 1960.

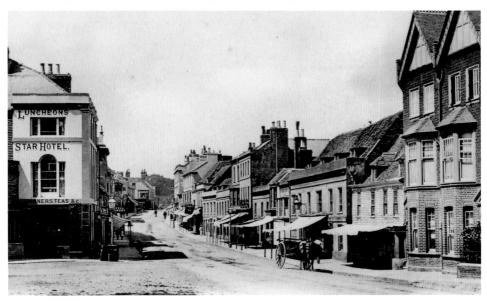

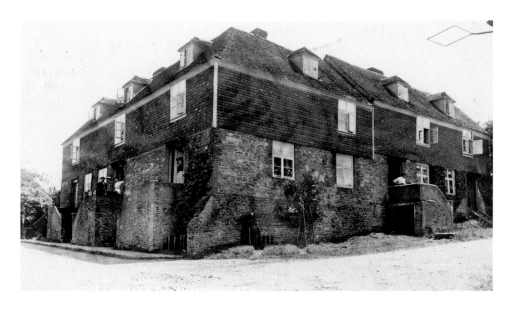

### Winchelsea, The Five Houses

These unusual dwellings, located at the east corner of School Hill and North Street, have changed little since 1908, when the above postcard was sent, and 2013. They were built in the 1760s, over repaired thirteenth-century cellars used in the preparation of flax, to house the workers of the English Linen Company. Not far away is Barrack Square (Factory Square in pre-Napoleonic times), whose buildings date from the same decade and were erected for the same purpose. The factory had eighty-six looms attended by 160 spinners, winders and weavers. Most of the twenty-six apprentices were local orphans. Winchelsea has more medieval cellars (fifty-six known medieval and a few post-medieval) than anywhere else in England, apart from Norwich and Southampton. Most were built to service the wine trade with Gascony. Of the thirty-three currently accessible, a number are open to the public for educational tours. (*Photograph courtesy of Steve Comber*)

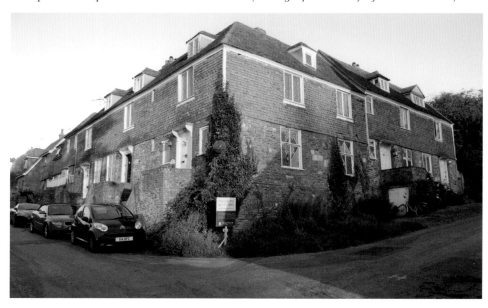

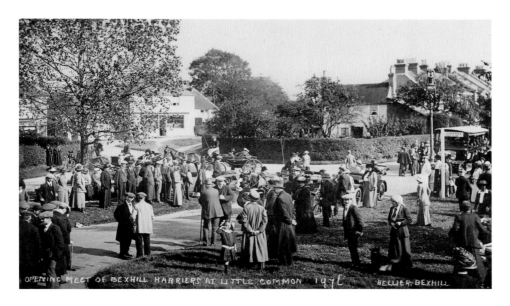

OPENING MEET OF BEXHILL HARRIERS AT LITTLE COMMON 1912    HELLIER BEXHILL

### Little Common, The Crossroads

The contrast between these views is surely one of the most remarkable in this book. This postcard was produced by brother and sister Archibald Douglas and Violet Constance Hellier, whose business was by 1911 named A. D. Hellier & Co. It was at that time based in Little Common itself, at 'Mayfield', Meads Road. We can assume the photograph predates the First World War, since the Bexhill Harriers were disbanded in 1915. Meets did not always end without incident: in April 1910, Major J. H. Gwynne, of Sandhurst Lodge, Little Common, died from injuries caused by his horse falling on him during a hunt with the pack. The village of Little Common developed in the early nineteenth century around the crossroads (today's roundabout) on the main road from Hastings to Pevensey. This, the present-day A259, is the ascending road on the right-hand side of these images.

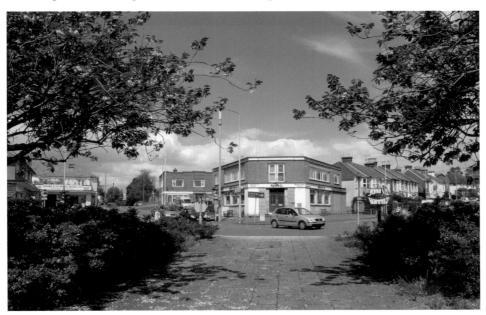

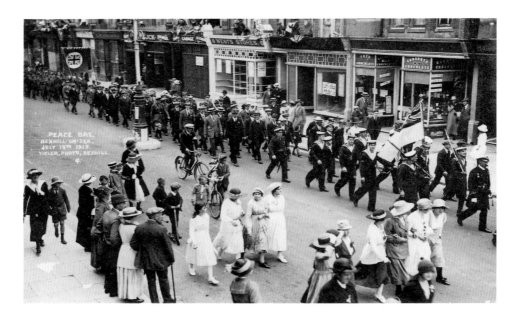

### Bexhill-on-Sea, Sackville Road

A strong local rival of the Helliers was the postcard publisher Herbert Vieler (1878–1950) of Bexhill. This fine study of the Peace Day celebrations on 19 July 1919 is a good example of his work (Vieler had himself served his country in the Royal Flying Corps). The town's splendid war memorial on the seafront, which records the supreme sacrifice made by the men and women of the town in the First World War, was unveiled on 12 December 1920. Bexhill ('-on-Sea' was added in 1883) lies between Eastbourne and Hastings. In comparison with them, it developed late as a resort. The impetus came in the 1880s from the 7th Earl De La Warr – by 1900, the population had tripled to 18,000 from 6,000 in 1880. In a 2007 national survey, Bexhill-on-Sea was voted the third best seaside town in which to live.

## Hastings, Wellington Place

These formidable-looking pirates were just two of 14,231 who became record breakers on 22 July 2012 when the town's traditional Pirate Day was held. A new Guinness World Record was established and the crown was wrested back from rival Penzance. Missing from the modern view is 'the Memorial', a clock tower erected to commemorate Albert, the Prince Consort. It was built in 1863 but the clock and dials were not installed until the following year. It stood until 1973, when it was demolished, being deemed unsafe following an arson attack in April and a smaller fire in June. In 1801, the population of Hastings was a mere 3,175; with the first train which arrived fifty years later, the town's dramatic rise as a seaside resort began. Today, the population is estimated to be around 87,000.

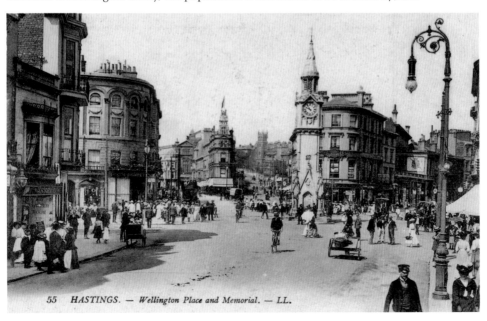

55  HASTINGS. — *Wellington Place and Memorial.* — LL.

### Eastbourne, Terminus Road (Ex-Victoria Place)

Eastbourne, a popular tourist destination boasting record hours of sunshine, was developed as a resort from the early nineteenth century, with its growth boosted by the arrival of the railway in 1849. By 1911, when it became a County Borough, its population had risen from under 4,000 in 1851 to 52,542. In the exceedingly rare postcard above, two four-horse charabancs are in front of the premises of Messrs Chapman & Sons at No. 1 Victoria Place, today's south end of Terminus Road. Soon, Chapman would be operating a fleet of motor charabancs – a feature from *The Commercial Motor* of 11 June 1914 described a six-day tour of the south and west covering a distance of 660 miles. Later came coaches and high-quality motor cars. An advertisement from 1926, by which year Chapman had three more premises in Eastbourne, shows a large number of them lining both sides of a square in the town.

**Pevensey Bay, Richmond Road**

A historical remnant in this diminutive resort, located 4 miles from Eastbourne and whose half-shingle/half-sand beach is known as the landing place for William the Conqueror, is this row of three charming ex-fishermen's cottages dating from the eighteenth century. The one nearest the camera, The Cabin, bears the date 1737; its neighbours are named The Little Cottage (No. 18) and Hook Cottage (No. 16). The number 17, on whose first-floor frontage is a remarkable plaque depicting two horses fighting, is taken by one of the six properties opposite. This row of houses has unusual arched windows on the first floor but since August 1945 (when the postcard below was mailed) only four of the uniform narrow dormers appear to have survived intact, while a further entirely new one has been added to an extended residence.

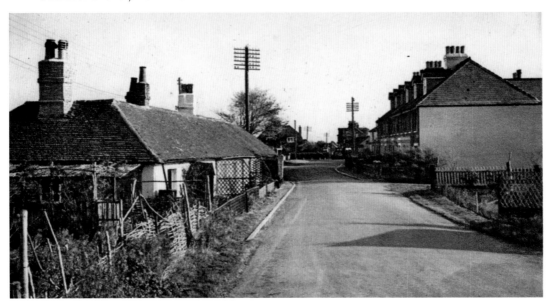

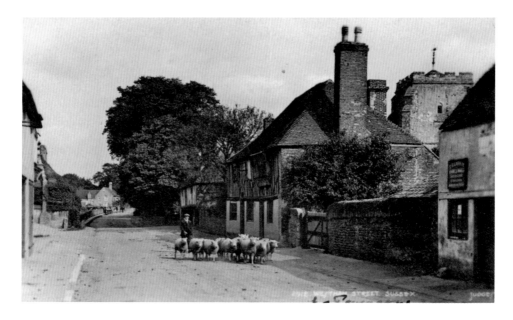

## Westham, High Street

Westham is located 5 miles north-east of Eastbourne and is adjacent to Pevensey. This street would once have traversed the grounds of third-century Pevensey Castle, occupied in 1066 by Harold's army, preparing to face William's forces. Westham's church of St Mary is reputedly the first Norman church in England, although there is a rival claim from Bramber. The tower seen here was not, however, added until the late 1200s. These historic houses are much photographed. In the far distance on the right is Oak House, which dates from the early sixteenth century. Its neighbours, Old Dial House and Heron Cottage, are of the same age. The property was originally a single dwelling but has, sadly, been divided. The date stone in the front wall of Old Dial House inscribed '1662' is a mid-nineteenth-century incorporation.

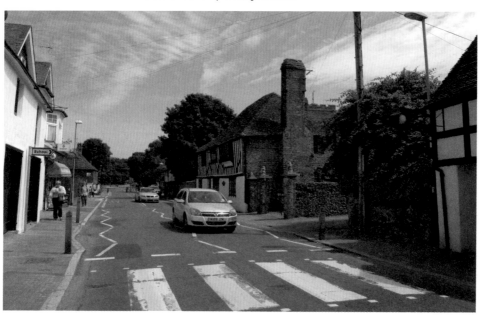

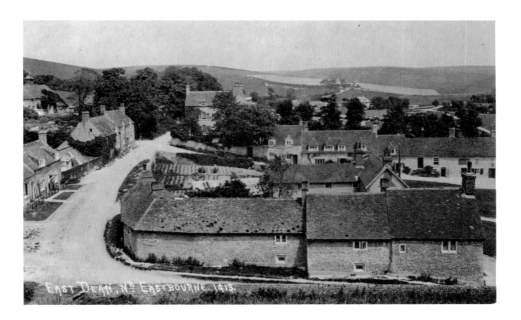

EAST DEAN, N° EASTBOURNE. 1413.

### East Dean from the Coach House

Nestling in a dry valley 3 miles west of Eastbourne and close to Friston, with which it forms a civil parish, East Dean was for centuries in the hands of the Davies-Gilbert family (the adventurer and explorer Sir Humphrey Gilbert, *c.* 1539–83, was an elder half-brother of Sir Walter Raleigh and founded the first English colony in America). The popular Tiger Inn overlooking the extensive village green takes its name from the family's coat of arms, despite the fact that the animal depicted is a leopard! The substantial dwellings of modern East Dean cover much of the Downs, seen in the early view above.

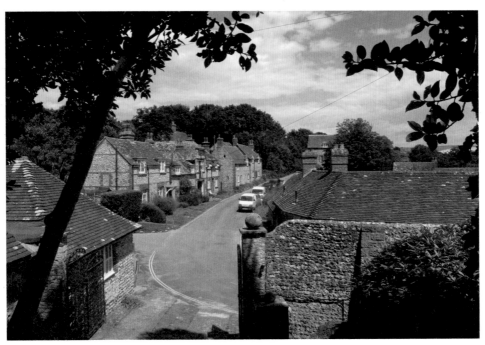

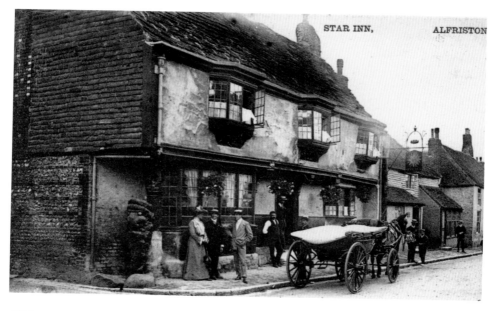

## Alfriston, The Star Inn

This ancient hostelry, delightfully portrayed in the above Edwardian postcard, stands in the High Street at its junction with the aptly-named Star Lane. Dating from the thirteenth century and called the 'Star of Bethlehem' until at least 1520, the inn served as a resting place for pilgrims on their way to and from Chichester but later in its history was a base for smugglers! The red lion figurehead, now standing further back, is thought to be from a Dutch warship which sank in the Channel. Now an award-winning hotel, the Star has been extended and altered down the years and boasts thirty-seven bedrooms. Alfriston village lies in the Cuckmere Valley some 4 miles north-east of Seaford and attracts many visitors all the year round to its quaint shops and buildings.

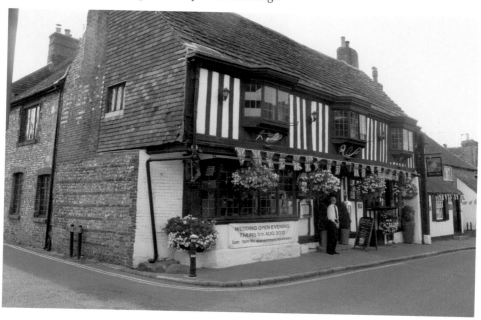

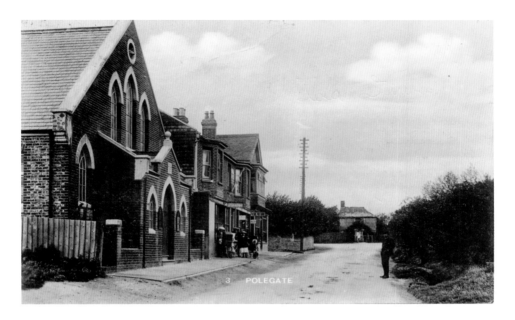

## Polegate, High Street

Early postcards of Polegate, a town located 5 miles north of Eastbourne, are (in this author's experience) few and far between. The above view dates from between 1904, when the Congregational church (today Polegate Free Church) was built, and 1910, when the old toll house in the distance was demolished. The house dated from around 1785 and stood in an area known as Swine's Hill Gate. It was superseded as a toll house in 1820, when the gates were moved to the bottom end of the High Street. Polegate developed as a railway settlement but this importance was lost with the closure of routes. A restaurant and bar now occupy the premises on Station Road, which served as the town's station from 1881 to 1986; today's station has, since that date, stood in the High Street.

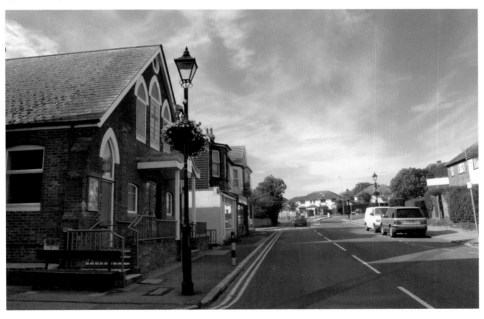

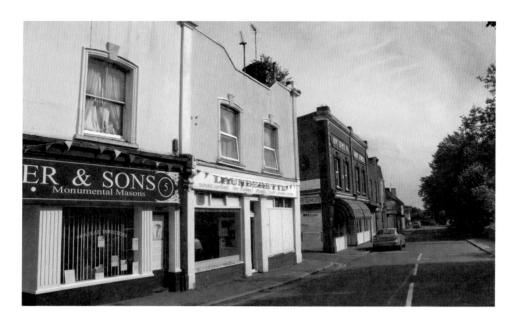

### Hailsham, Station Road

The market town of Hailsham, the largest of the five main towns in the Wealden district, lies 8 miles north of Eastbourne. It had a passenger rail link to Polegate from 1849 to 1968 and to Heathfield and Eridge (for Tunbridge Wells) from 1880 to 1965. The southern 12 miles of the Cuckoo Line, as it was known, have become the popular cycleway/footpath known as the Cuckoo Trail, which passes close to Station Road. A funeral director's, a launderette and an outdoor clothing/equipment store now occupy Nos 5–9 inclusive, premises formerly occupied by Laurence the grocer and Thomas Davis the carriage builder; the latter, a native of Battle, plied his trade here for over twenty-five years until his death in 1920. His son, John, then carried on the business, latterly as radio and electrical engineer and cycle agent, until around 1971.

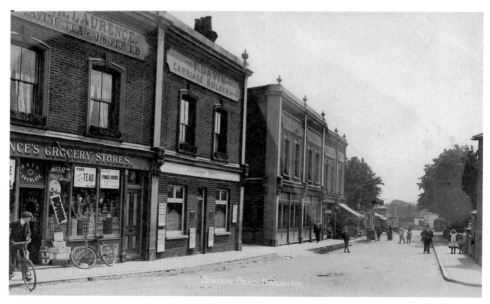

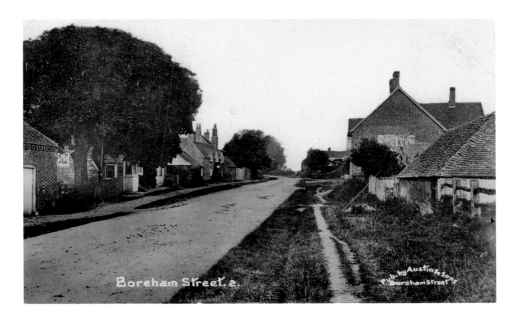

Boreham Street, 2. Pub. by Austin & Sons, Boreham Street

## Boreham Street

Located 4 miles east of Hailsham, Boreham Street is an attractive hamlet on the road between that town and Ninfield (the original Roman road ran from Lewes to Beauport Park, Hastings). Recorded in the Domesday survey as having a population of 280, Boreham boasts a thirteenth-century church and many beautiful residences, including Boreham House of 1796, undergoing sensitive renovation at the time of my visit. Boreham lies within the parish of Wartling, much of whose history it therefore shares. The settlement has a strong smuggling tradition, and a tunnel from today's listed Smuggler's Wheel restaurant formerly linked a number of properties. Boreham Farm Cottages behind the hedge on the right date from the 1860s; near them, several properties are tasteful conversions of former farm buildings, among them an oast house.

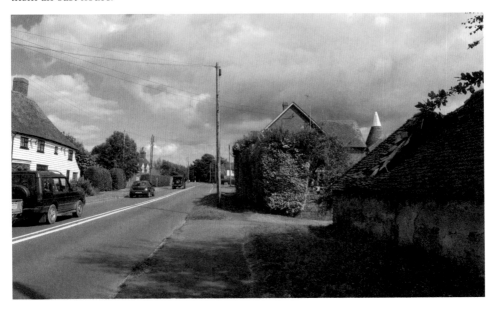

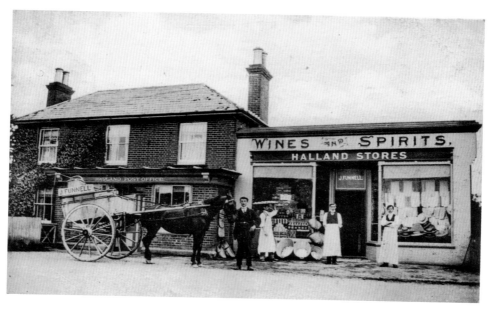

## Halland, Lewes Road

The small village of Halland, straddling the junction of the Lewes to Blackboys road (the B2192) and the Eastbourne to Purley road (the A22), lies within the civil parish of East Hoathly with Halland and was until the 1890s referred to in local directories simply as 'The Nursery'. It has historical links with the local iron industry. Early last century, the post office and stores were in the hands of John Funnell, who in 1901 had an apprentice and an assistant in his employment; the business was previously run by his father Trayton, who had died in 1899. Since 1972, Joseph and Lily Elliott have occupied the house, named Fourways (doubtless after the roads converging on the nearby roundabout), running the shop until 1975, when they demolished it and added the site to their garden.

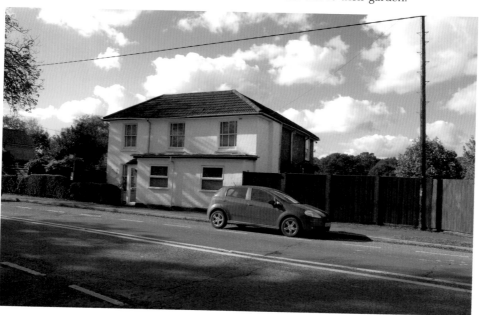

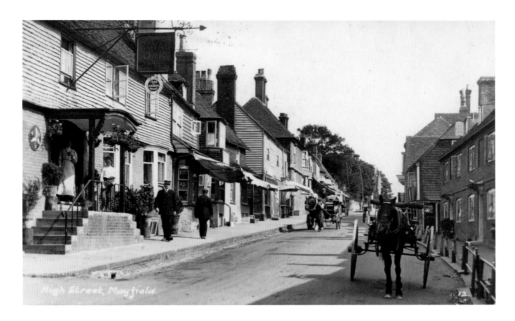

## Mayfield, High Street

This splendid animated view was produced by noted Tunbridge Wells postcard publisher Harold Camburn for Mayfield retailer Herbert Scammell. The High Street, in which the Royal Oak Hotel looms large, has changed little down the years. The hotel was once an inn, which by 1602 was called The Oak and by 1786 the Royal Oak. It was converted to residential use in the late 1980s, when the substantial property (extending rearward some way into Royal Oak Mews) was divided into four dwellings. Described by the poet Coventry Patmore as 'the sweetest village in England', Mayfield, located 10 miles south of Tunbridge Wells, flourished during the boom in the Wealden iron industry, but has had its share of misfortune, suffering a major fire in 1389 and further damage in 1621 when St Dunstan's church was struck by lightning.

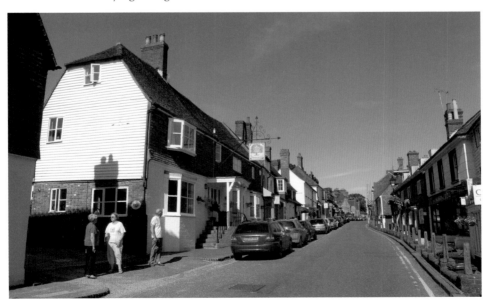

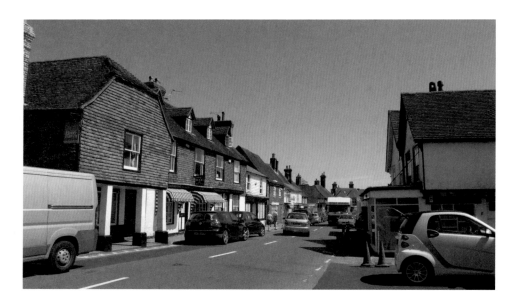

### Wadhurst, High Street

Located near the Kent/Sussex border 7 miles east of Crowborough, the small market town of Wadhurst was once (like nearby Ticehurst) deeply involved in the iron industry. Among the interestingly varied buildings lining the long High Street is the projecting Clock House on the left, thought to date from the seventeenth century. It was at the time of the early picture below the home and shop of Harry 'Clocky' Newington (1876–1966), horologist, tobacconist, silversmith and church clock 'minder'! Two inns/public houses have been lost in this stretch of the street: the White Hart, now letting agents Ashton Burkinshaw (although, confusingly, there is still a White Hart pub in the village) and the then 500-year-old Queen's Head (well beyond the gabled businesses on the right), destroyed on 20 January 1956 by an RAF night fighter jet crashing into it and exploding. The crew of two (one with a local family connection) and two villagers were killed.

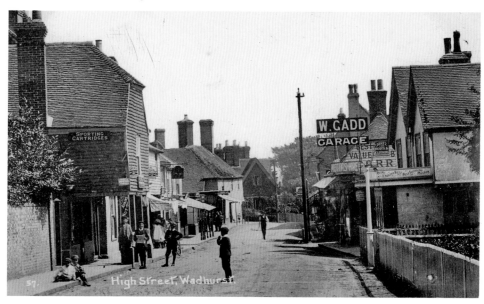

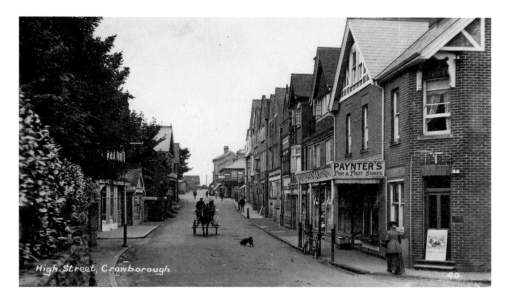

## Crowborough, High Street

We are looking north towards the major intersection of Crowborough Cross, where the east–west A26 Beacon Road/Eridge Road cuts across the High Street, which continues north as London Road. The left, or west, side of the street has seen the loss of, *inter alia*, the London & County Bank (note the archway), St John's Laundry and the Clock House Dairy. The second gabled property is of interest, since it served as the fire station for several decades from 1904; Frank Humphry, a Crowborough solicitor, helped to set it up. He became Captain of the brigade for twenty-five years until his death in 1928. Across the road is more continuity: W. E. Cro & Son, jewellers, has been run by the family on the same premises since 1924. Crowborough boasts good road and rail links and is the largest inland town (by population) in East Sussex.

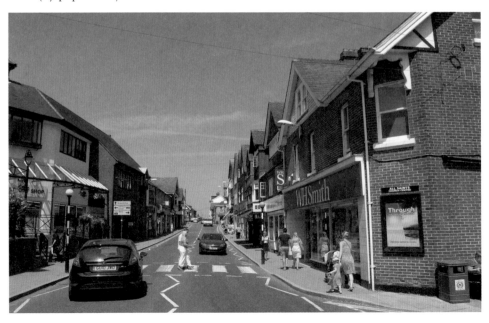

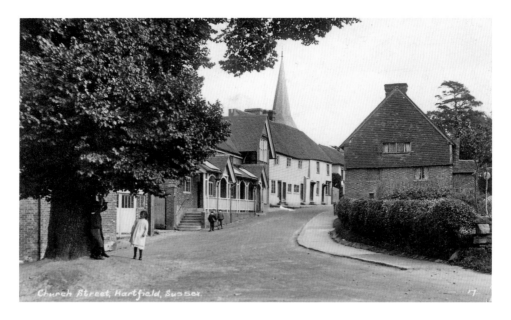

Church Street, Hartfield, Sussex.

## Hartfield, Church Street

Located on the northern edge of Ashdown Forest, roughly between Tunbridge Wells and East Grinstead, Hartfield is a popular tourist destination. The main fabric of St Mary's church (whose shingled spire appears in both photographs) dates from the thirteenth and fifteenth centuries and is Grade I listed. Nos 1–3 Church Street are among the many listed buildings in the village. Built in the fifteenth century, they were originally a single hall house. The Anchor Inn is also of this period. For at least a century it was the workhouse, with fifty-four inmates in 1821, until it became an alehouse in around 1865. A shop in the High Street nowadays specialises in Winnie-the-Pooh, whose creator, A. A. Milne, had what he once called a 'weekend cott' nearby from 1924 until his death there in 1956.

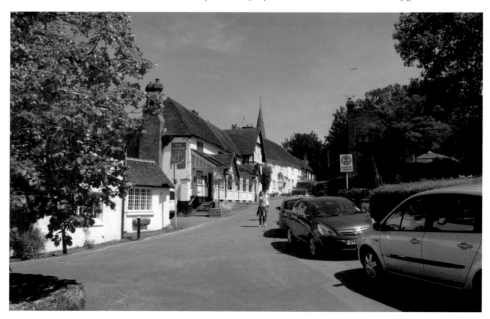

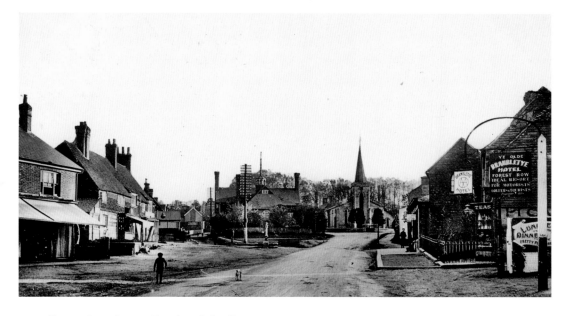

## Forest Row, Lewes Road and the Square

Largely out of sight on the right is the Brambletye Hotel (at which Sherlock Holmes and Dr Watson stayed in *The Adventure of Black Peter*); originally built as a private house, it became a hotel in 1866. Next door is the part-sixteenth-century, Grade II listed Post Cottage, while over the road stands the Chequers Inn Hotel, dating from 1452. The central island, now screened by trees, is occupied by the village hall, across the road from which is Holy Trinity church, consecrated in 1836. Forest Row grew from a small hamlet to a sizeable village thanks to its eighteenth-century turnpike road and its rail link, from 1866 to 1967, to Tunbridge Wells and East Grinstead. The latter, in neighbouring West Sussex since 1974, lies 3 miles to the north-west.

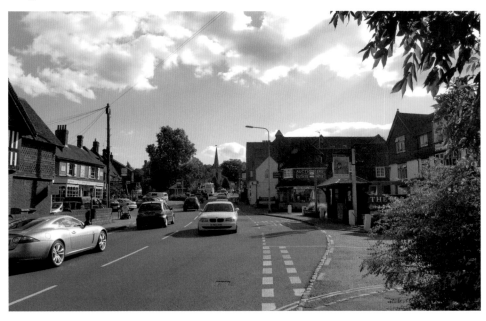

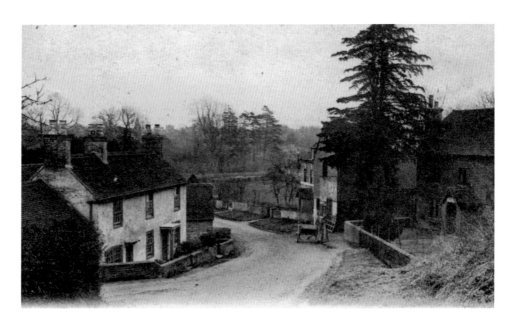

### Maresfield, Underhill

Surprisingly, Underhill, the road that ran from London down Chequers Hill, was industrial in the nineteenth century, being the location of the village forge, a tanyard and a bakery. During the First World War, the forge gained importance through the large number of Army horses shod there. On the left are the Grade II listed sixteenth-century Hillside and Wistaria (*sic*) Cottage – the latter functioned as a common beerhouse in the nineteenth century. The tanyard was located in the field behind it. On the right stands the likewise Grade II listed Forge Cottage, once a baker's premises. The adjacent tall granary has disappeared. Further down Nursery Lane is Tanyard Farm of 1760, where the tanyard owner/manager lived. Maresfield, a community with a population of over 3,000, is located 1½ miles north of Uckfield.

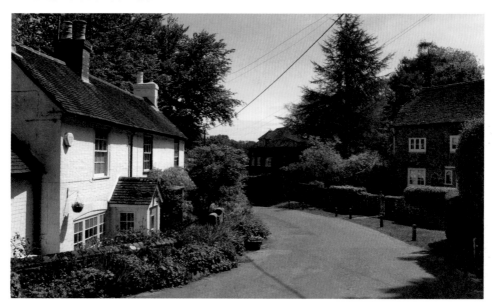

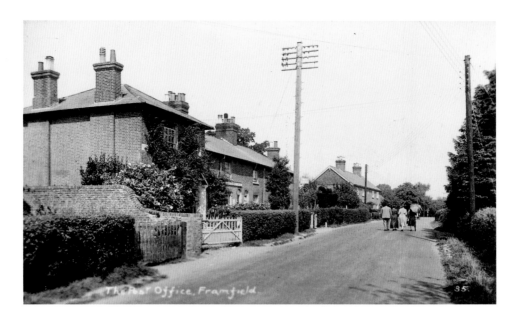

## Framfield, The Street

Next door to Georgian Sunnyside House (formerly Villa) on the left is Sunnyside Cottage, the site of one of three now defunct post offices, all in The Street, to have served the village of Framfield, 2 miles east of Uckfield, down the years; it is now a residence. Adjacent are Nos 1–2 Salem Cottages, while in the distance are Ebenezer Cottages of 1882. By the 1970s, the post office was housed briefly in the old village shop (now a house called The Coach House) then moved to the rear of builders' offices formerly belonging to Press and Banks and currently to D. F. Tourle Ltd (builders and decorators). The 6,700 acre parish area of Framfield includes the settlements of Blackboys, Palehouse Common and Halland. Its once important iron industry, in decline from the mid-1600s, ceased in the Weald in the early nineteenth century and moved north to the coal-rich Midlands.

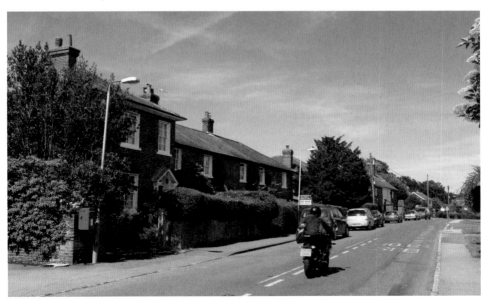

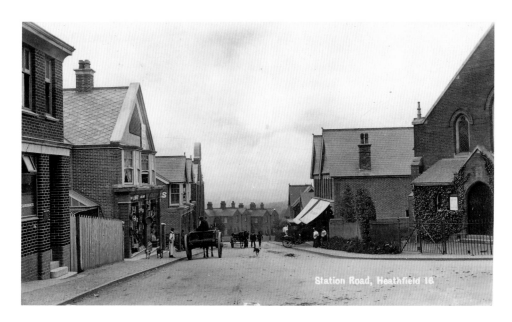

Station Road, Heathfield 16

### Heathfield, Station Road

The small market town of Heathfield lies almost equidistant (approximately 16 miles) from Tunbridge Wells and Eastbourne and is located near the junction of two main roads: the A267 between Tunbridge Wells and Eastbourne and the A265 from Hawkhurst. The above view from the High Street, on a postcard posted in 1911, looks south-eastward over the High Weald towards the South Downs. The distant building on the left with a tall façade is the Recreation Hall of 1909, now State Hall the home of Kingschurch, while on the immediate right is the Union church (Congregational and Baptist) built in 1899–1901. Today's view is enlivened by a steam engine en route to the annual fundraising Steam Rally at Tinkers Park, Hadlow Down.

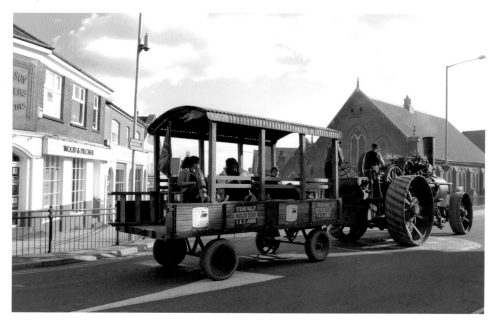

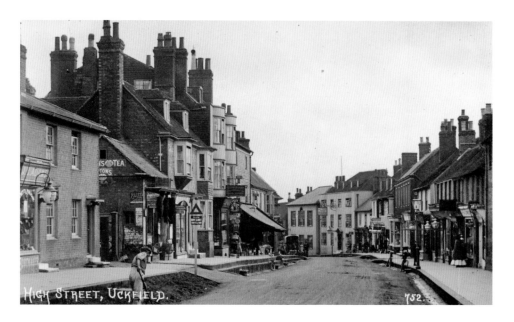

**Uckfield, High Street**

Located some 7 miles north-east of Lewes, Uckfield was established on higher land away from the flooding-prone River Uck. Its mainstay was originally agriculture, its market being of major local importance. Bypassed to the west by the A22, Uckfield lost its rail link to Lewes in 1969 after more than 100 years of operation, although the connection to London via the Oxted Line survives. Depicted here is the northern part of the High Street, with its unusual stepped kerb. Further south, on the right, may be seen the Grade II listed Maiden's Head Hotel, once an important coaching inn. The High Street forms the backbone of the north-eastern portion of the Conservation Area first designated by East Sussex County Council in 1968; its boundaries were reviewed by Wealden District Council in 1998.

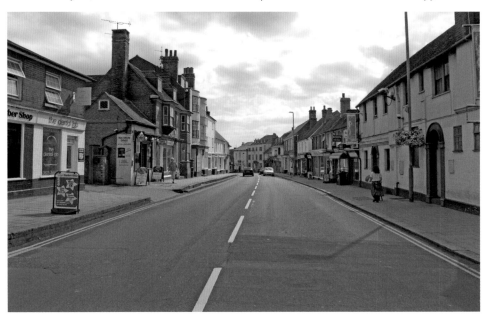

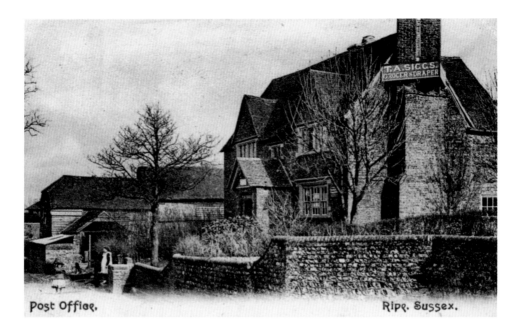

Post Office.                                          Ripe. Sussex.

### Ripe, The Post Office

Today the post office and stores in the village are housed in nearby Burton Cottage, a seventeenth-century listed building on the main village square, but here we see Eckington House in Ripe Lane, dating from the same century (specifically *c.* 1620), being used for the purpose. It was originally built as a gentleman's house for a wool merchant from London and at one time butter was made in the cellar as well as ale and cider from apples in the orchard. Roman stones have been identified in the foundations. The postcard, showing Thomas Alfred Siggs as the resident grocer and draper, was posted on 31 December 1907 from Shortgate, near Uckfield, to Notting Hill, London. The village lies 7 miles east of Lewes and 7 miles west of Hailsham, with Berwick station located 3 miles to the south.

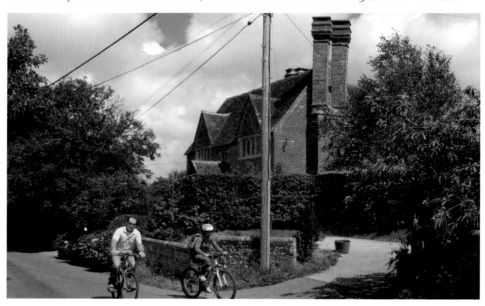

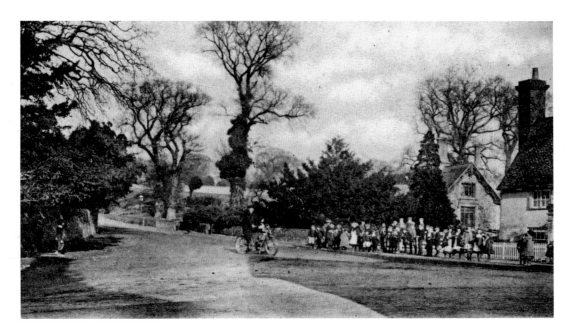

## Glynde

Lying 2 miles east of Lewes, on the flank of Mount Caburn, the attractive village of Glynde, where John Ellman first bred the renowned Southdown breed of sheep, is well served by communications. It lies not far north of the A27 linking Lewes and Eastbourne and has a centrally located station, to which no fewer than three industrial lines working nearby pits were once connected. The railway arrived in 1846 and was electrified in 1935. Behind the delightful assembly of children above stands the Village School of 1842, today divided into two cottages; in the foreground on the right is Wisdom's, a cottage which had belonged to a succession of village carpenters since the late seventeenth century and was bought in 1756 by carpenter John Wisdom.

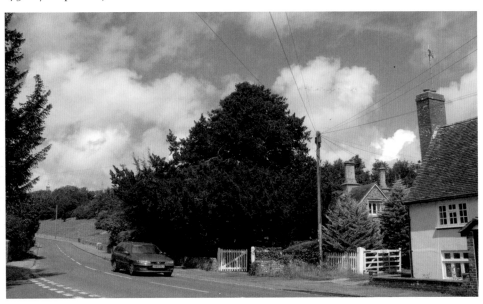

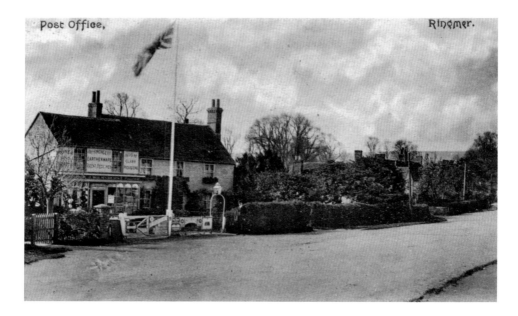

### Ringmer, Lewes Road

Three miles north-east of Lewes lies the large village of Ringmer (the 'Ring of Pools'), mentioned in the Domesday survey. It is intersected by the B2192, or Lewes Road, which links the county town with Blackboys. The post office and stores, from which William John Wilmshurst sold, *inter alia*, earthenware and patent medicines, as proclaimed above, has become Amberly Cottage. Despite a plaque denoting 'ca. 1750' as the build date, it was erected in the following century as an extension to the weatherboarded cottage on the right named 'The Firs', originally a smallholder's cottage. The post office closed in the 1990s and the adjacent land was developed into today's Olde Post Office Mews. Around 2000, the original building was divided into three flats, the first floor one of which is here advertised for sale in October 2012.

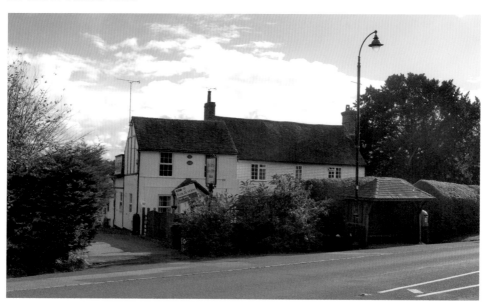

## Newick, Church Road

We are standing at the junction with Blind Lane and looking north. Some way ahead, where long Church Road ends, is Newick's spacious triangular green, which looks out to open country rather than being the centre of the village. In the mid-distance, obscured from view, the properties numbered 51 (Choisya), 53 and 55 form a Grade II listed nineteenth-century terrace. The tall property with two chimneys is Burnt House, No. 47, and is likewise Grade II listed. This well-proportioned, three-storey residence has black mathematical tiles facing the two upper floors and dates from the early part of that century. Further on, the Victorian Reading Room, home to the village's preschool, is another prominent building within this conservation area. Newick, whose Saxon name means 'new farm', lies 4½ miles west of Uckfield, 8 miles north of Lewes and 6 miles east of Haywards Heath.

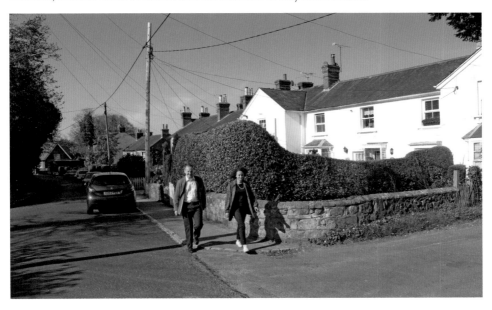

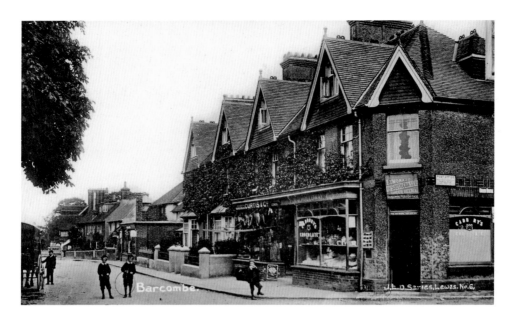

## Barcombe (Cross), High Street

The village of Barcombe Cross, known as Barcombe in the local area and also to the Royal Mail, lies 4–5 miles north of Lewes and is one of three in the district to bear the Barcombe name, the other two being the original Barcombe and, on the River Ouse, Barcombe Mills. The two railway stations which once served the area, Barcombe (Lewes–East Grinstead) and Barcombe Mills (Lewes–Uckfield) closed in 1958 and 1969 respectively. Featured here are the Victorian, roughcast-faced Gladstone Buildings (numbered 1 to 4), which date from around 1873. In part and for many years they housed retail premises and No. 2 was even – from some time after the war until 1964 – run as a fire station. Today the properties are purely residential. The early postcard dates, on publication data evidence, from 1910 or later.

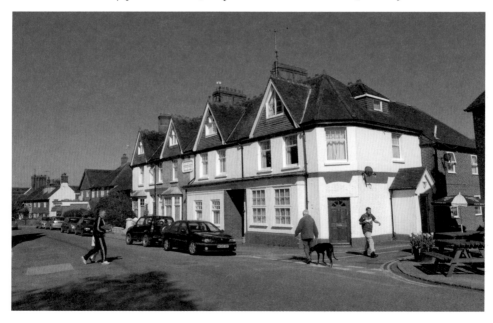

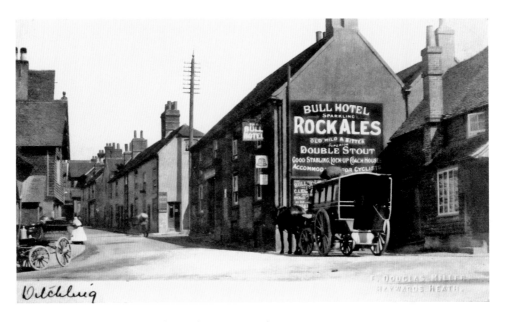

*Ditchling*

### Ditchling, The High Street from the Crossroads

This rare postcard was published in 1904 or later by Douglas Miller of Haywards Heath. Dominating the picture is the stuccoed Bull Hotel, whose origin can be traced back to 1563, although the present building (Grade II listed, as are many in the High Street) dates from the early nineteenth century. There was a romantic link between The Bull and Fieldwick's, the shop out of sight on the extreme left where the cart is standing, for in 1894 Joseph Sheppard Fieldwick married Edith Emily Lidbetter, the daughter of the innkeeper Sarah Lidbetter. The distinctive buildings opposite The Bull are heavily restored timber-framed structures. Further up the High Street stands Sopers, once occupied by sculptor Eric Gill, who arrived in the village with his family in 1907. Perhaps best known for the artists and craftsmen who have lived and worked there, Ditchling lies at the foot of the South Downs, 8 miles north of Brighton and 8 miles north-west of Lewes.

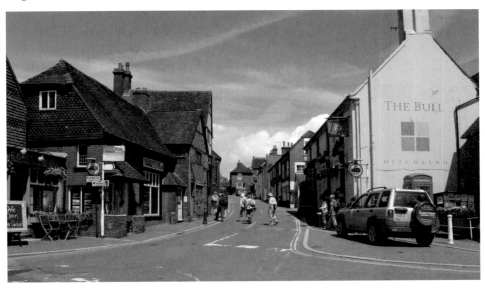

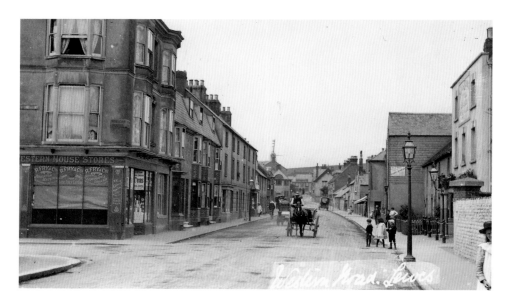

## Lewes, Western Road

Originating as a Saxon settlement, the county town of Lewes lies approximately 7 miles north of Newhaven and an equal distance north-east of Brighton, at a gap in the South Downs and along the River Ouse (it was formerly a river port of some importance). The ruins of the eleventh-century castle still dominate the bustling town, where tourism and the arts are of importance. Some light industry is carried on and Harvey's Brewery, founded in 1790, is justly renowned. Western Road leads towards the prison, built in 1850–54, and is intersected by the Greenwich Meridian (the public house on the site was renamed The Meridian in the year 2000 but was demolished ten years later, being supplanted by townhouses named Meridian Row). By contrast, the Black Horse Inn on the right of the picture still stands firm after just over 200 years of existence, although its stables were demolished in the 1960s.

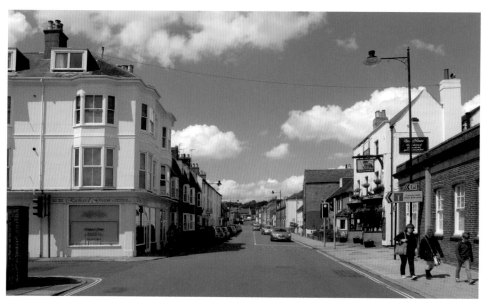

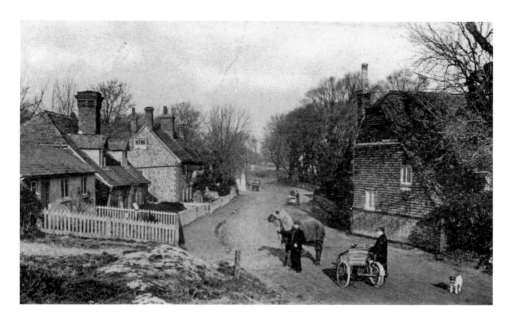

## Offham, The Street

Offham lies immediately north of Lewes within the parish of Hamsey, which includes the villages of Hamsey, Offham and Cooksbridge, on the fairly busy A275 to East Grinstead. Unusually, the parish possesses two churches both dedicated to St Peter, one in Hamsey and one in Offham, the latter, consecrated in 1860, being the more recent. The village buildings pictured have changed little down the years, with Yew Tree Cottage still prominent on the right. On the left stands Toll Cottage, originally the property of Hamsey Place Farm, and next to it, with a pair of dormers, the Old Granary. Beyond that are Nos 7–10 Offham Cottages, an eighteenth-century farmhouse converted into four estate cottages during the following century.

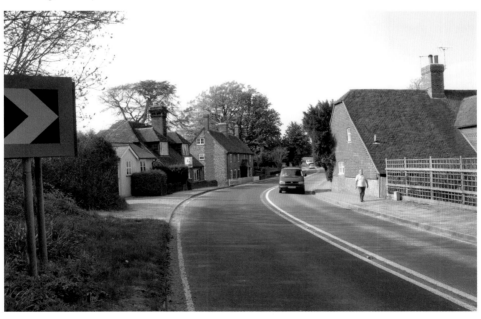

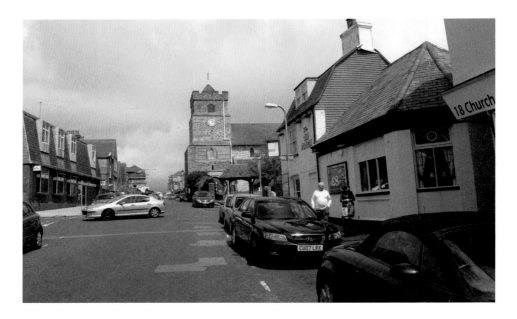

### Seaford, Church Street

The quaint shops and interesting buildings we can see below on the left-hand side of this street were lost through bomb damage by a lone German aircraft on 1 April 1941. Today, a block numbered 37 (out of sight here), adjoining West Street, houses municipal offices, the tourist information office and the police station; further up may be seen the post office building put up in 1976. St Leonard's church dates from 1090 but has undergone many alterations down the centuries. By contrast, the Old Plough Inn (right) dating from the 1600s, has changed little. Lying east of Newhaven and Brighton and west of Eastbourne, the quiet resort of Seaford, connected to Lewes and London by rail since 1846, is the largest town in Lewes District, with a population of some 23,000. Its status as a port was lost after the River Ouse changed its course in the late sixteenth century.

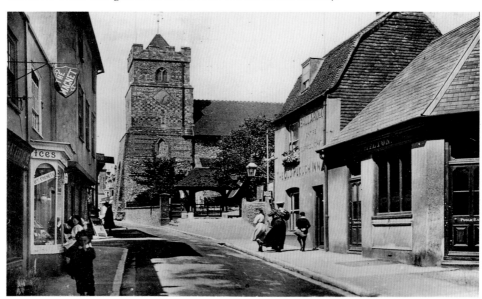

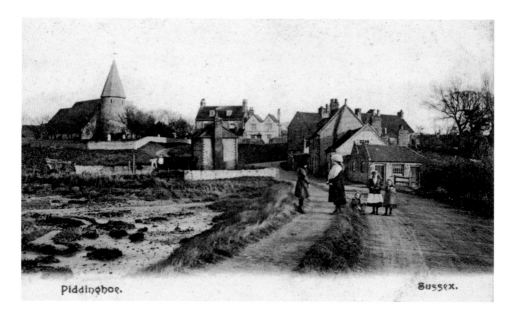

Piddinghoe.          Sussex.

### Piddinghoe, The Street

Located on the River Ouse, a couple of miles north-west of Newhaven, Piddinghoe has been screened from the Newhaven–Lewes road since 1923 when a bypass was built. Smuggling was rife here in the past, but today the creek attracts dinghy sailors and windsurfers. The Muddy Islands on the left of the old photograph showing Gertie and Katie Penfold on the path were a favourite playground for local children. Trees now obscure the Norman church of St John's, one of three with a round tower in the Ouse Valley, but the weather vane featuring a salmon remains visible. On the right, the range of eighteenth-century Blythe Cottages has changed little, although Old Cottage opposite with the tall chimney has been much extended.

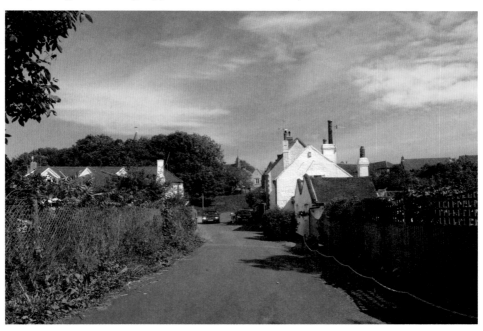

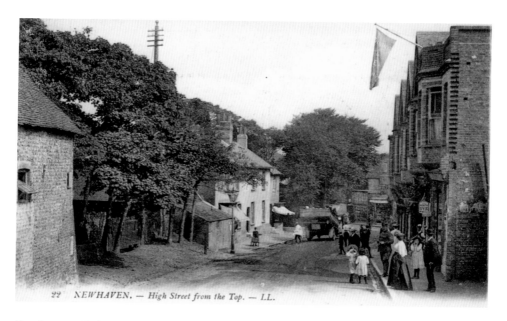

22 *NEWHAVEN. — High Street from the Top. — LL.*

## Newhaven, High Street

The River Ouse meets the sea at Newhaven, an important port since the mid-sixteenth century, when a sheltered harbour was created. Improvements to the harbour between 1850 and 1878 enabled it to be used by cross-Channel ferries. The main part of the town is located on the west side of the river and here we see the High Street long before it, and the surrounding area, was isolated by a ring road formed by the A259 coast road in 1974. In those happier days, the Thornycroft 80 B4 charabanc in the picture, purchased new in 1907 by the Sussex Motor Road Car Company of Worthing, will have just made the journey from that town. The old farm building on the left has been replaced by a post office sorting office, although the villas in the middle distance have survived, living on as business premises.

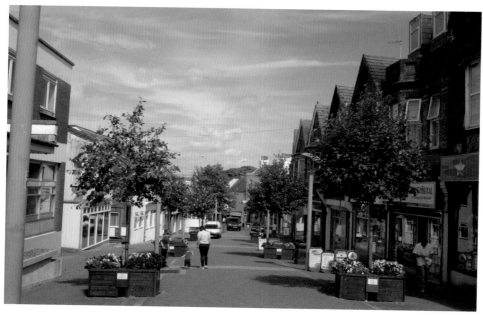

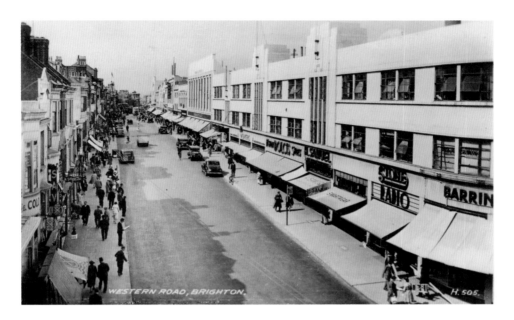

## Brighton, Western Road

It is difficult to imagine that this major thoroughfare in today's buzzing and densely populated resort was once a track between fields in the West Laine area of the town. It took its name from one of the landowners, Thomas Western, rather than from emerging as the main route west from Brighton to Brunswick Town (just within Hove parish). The above view illustrates well the Art Deco frontage (now sadly lost in part) on the northern side of the street, with the entrance to Imperial Arcade, built in 1923 and rebuilt in 1934, more clearly visible near the taxi in the lower photograph. The most dramatic change between the images took place on the left, where Churchill Square, on which work began in 1965 with the formal opening in 1968, now stands in place of the retail outlets seen above.

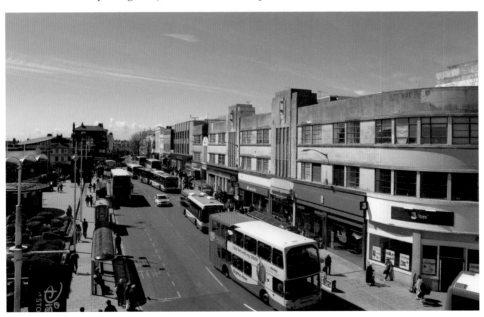

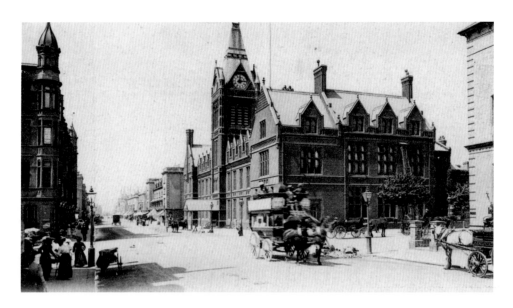

## Hove, Church Road

More spaciously laid out and more genteel than Brighton, its larger neighbour, Hove was developed during the Regency and Victorian periods, and later administratively encompassed a number of smaller communities to the west. It was merged with Brighton in 1997, the conjoined towns being elevated from borough to city status three years later. Hove's former Town Hall at the junction of Norton Road and Church Road was built by John Thomas Chappell to the design of Alfred Waterhouse, dubbed the High Victorian Architect par excellence, and formally opened in December 1882. Much of the building was destroyed by fire – the worst in Hove's history – on 9 January 1966. No fewer than seventy firemen attended the blaze. In 1971, following much discussion, the ruin was demolished; the controversial new Town Hall (for which several nearby houses were sacrificed) was officially opened in March 1974.

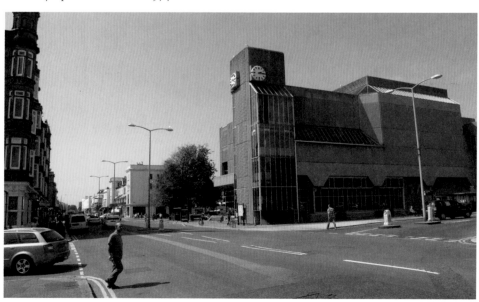

West Sussex

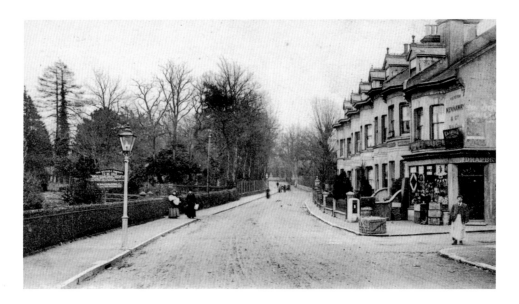

## Hassocks, Keymer Road

A milestone in the development of this large village some 7 miles north of Brighton was the coming of the London to Brighton railway in 1841. The above view shows, on the left, a substantial area of land (30 acres) advertised for sale by William Balchin, a market gardener who had been running a commercial nursery on the site. The new purchaser, Brighton businessman Frederick Wellman, created the Orchard Tea Gardens in 1908 (the ladies above are standing where the entrance would be located). To the roundabout, boat swings, helter-skelter and other attractions were added, in the early 1920s, a boating lake, switchback railway and miniature race track by the new owner, London businessman Villeroy Doubleday. The Pleasure Gardens, so renamed after the war, closed in 1935 following his death and the grounds were developed by George Ferguson into Grand Avenue and several other roads.

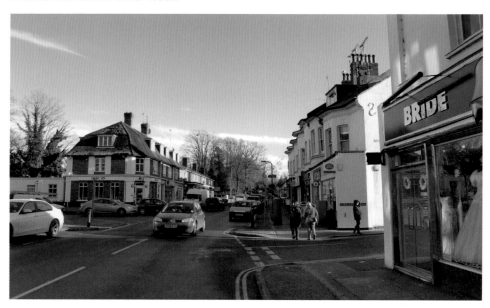

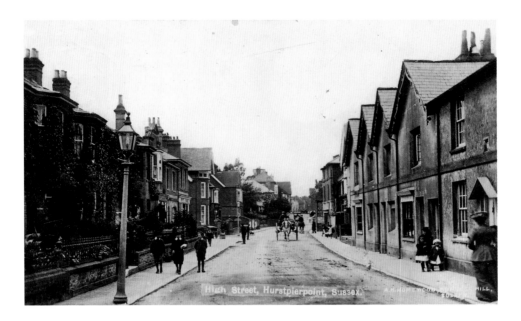

**Hurstpierpoint, High Street**

Shown here are properties on the village High Street facing north-west, just past the point where the Hassocks Road ends. The flat-roofed residence at the extreme left is the earliest in the row, built as cottages for workers of Hampton Lodge, having been put up in 1830 at the same time as the Lodge. The Hampton coat of arms is depicted as an inset on the façade. The gabled properties, of which two were evidently shops in the Edwardian era, followed in 1836. A similar row of gabled properties, erected later, adjoins the row behind the photographer. Hurstpierpoint village, located 4 miles south-west of Burgess Hill, is famed for its public school, Hurstpierpoint College. It had a population in 2001 of 6,264. It is linked to London and Lewes by rail from nearby Hassocks. (*Lower photograph courtesy of Andrew Hair*)

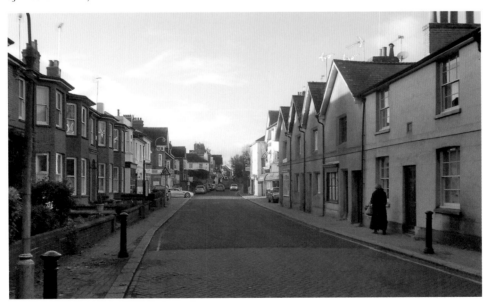

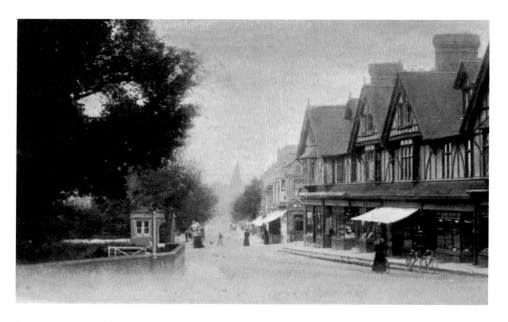

## Burgess Hill, Station Road

The large town of Burgess Hill, whose name derives from the farm referred to as Burgeshill Land in the sixteenth century – now the site of Oakmeeds School and the Chanctonbury estate – is predominantly situated just on the West Sussex side of the county border. It is located about 10 miles north of Brighton and Hove and 39 miles south of London. The coming of the railway in 1841 was the catalyst for the town's expansion. The land enclosed by the wall on the left was originally part of the above 'Land', later called Burgess Hill Farm, whose farmhouse and outbuildings were demolished in 1958; the car park opposite Wolstonbury Court, down the turning on the left, now stands on the site. The timber-framed buildings on the right, between Grove Road and Mill Road, are attractive examples of the late nineteenth-century Vernacular Revival style of architecture.

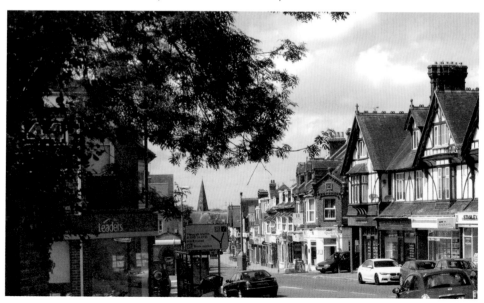

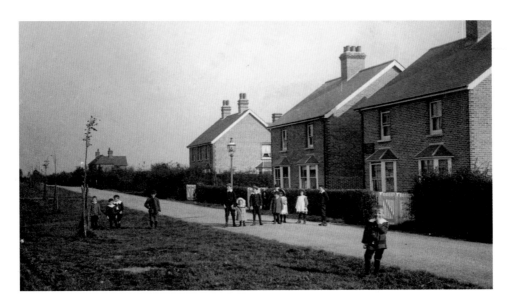

## Scaynes Hill, The Common and Church Road

The two semi-detached pairs of dwellings on the right, Nos 1–3 Fernlea and No. 4 Halsford, would have been very new at the time the above postcard was produced (they are understood to have been put up in 1908 as a speculative investment by local shopkeeper J. J. Luckens). The Pavings, built in 1963 on part of the extensive garden of Halsford, is one of several in-fillings in this road. The first of the saplings stands where the turning into Vicarage Lane is today, although the others have clearly flourished over the last century. The Common, once used by locals to graze their animals, is now a protected meadow of grasses and wildflowers. Scaynes Hill, very near Haywards Heath, is sited on the eastern border of West Sussex and is divided by the A272 trunk road. The village contains some 400 homes, largely surrounded by farmland.

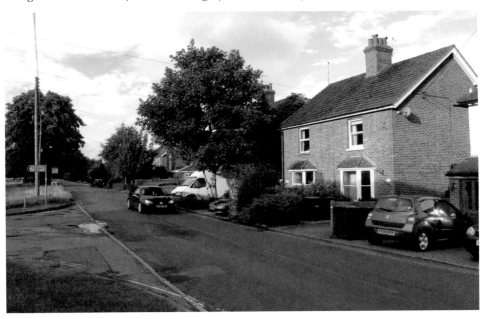

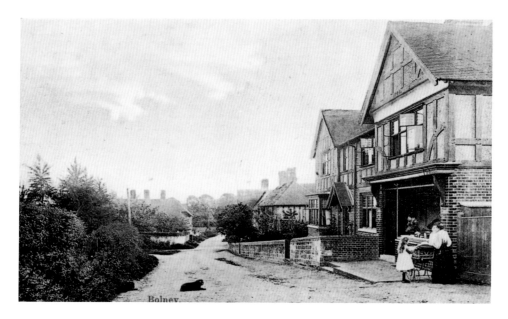

## Bolney, The Street

The two properties on the right were built in 1904 (see the nearest horizontal gable timber) and the above postcard featuring them was published some three years later. Today the twin houses are one and named 'Southdown House'. The former butcher's shop had a slaughterhouse to the rear but a house has been built in its place. The other shops and businesses in the road, including a shoe shop and bakery, have all gradually been converted to residential use. The Street, in which Saxon road timbers have been excavated, unites the two historical parts of Bolney – the main village clustered around the church and the Common to the north. Out of sight down on the left stands the war memorial. Noted in medieval times for its Cherry Fair and as a supplier of charcoal to some other Sussex villages for iron-smelting, Bolney is located just over 6 miles west of Haywards Heath.

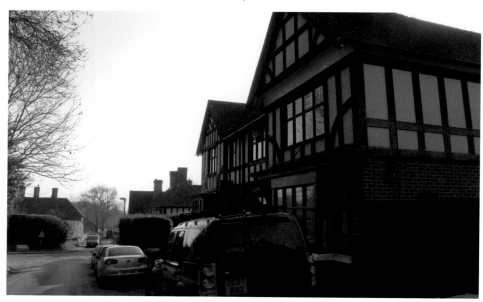

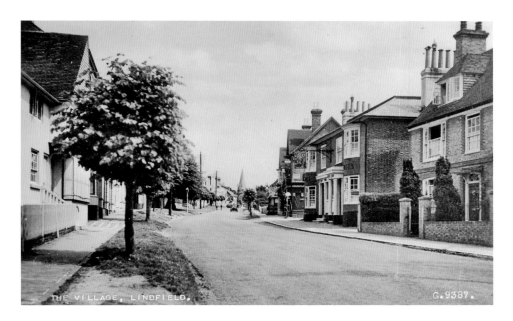

THE VILLAGE, LINDFIELD.    G.9387.

## Lindfield, High Street

One is unlikely ever to find Lindfield's High Street as deserted today as this Valentine postcard shows! The village name means 'open land with lime trees' and docked limes are still much in evidence. During the eighteenth and nineteenth centuries, the street, here gently rising northward, was on the turnpike route from Newchapel (north of East Grinstead) to Brighton. The main (southern) of the two toll gates stood in the foreground of these photographs – a nearby plaque records its removal in October 1884. Great jubilation accompanied the burning of both gates in a bonfire in the street on 5 November. Adjacent to Haywards Heath, Lindfield is a thriving historical village with an identity all its own. On the right stands Porters, which from 1804 to 1833 was the Red Lion Inn. The inn now stands next door. Humphrey's Bakery, canopied on the left, was established in 1796.

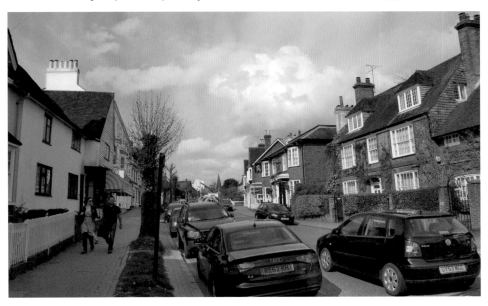

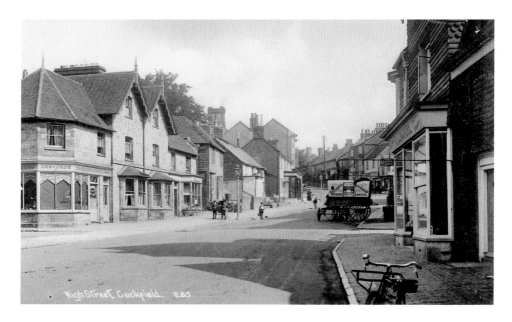

## Cuckfield, High Street

The substantial corner building on the left in this anonymously-published period piece, namely Cuckfield Lodge (No. 18), was built in 1871. From it, one Rubens Thomas Anscombe (1849–1932) was trading at this time as a plumber and decorator, and dealer in photographic materials. The cart up the road belonged to Southdown and East Grinstead Breweries Ltd, a company formed from several breweries in 1895 but which sold out in 1924 to Tamplin & Sons of Brighton. A large number of listed buildings line the High Street of Cuckfield, noted for its importance in coaching days. In 1761, the first direct road to London was made, rerouting the road to Brighton. When the London to Brighton Road (now the A23) was completed in around 1816, however, stagecoach traffic here decreased sharply. The last commercial stagecoach called in 1845 and the last mail coach in 1905.

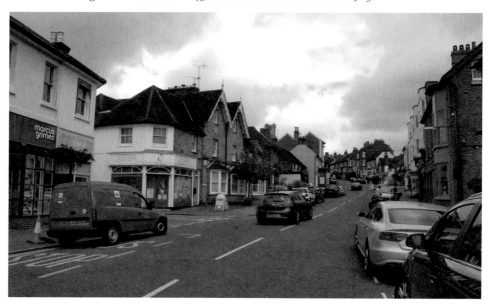

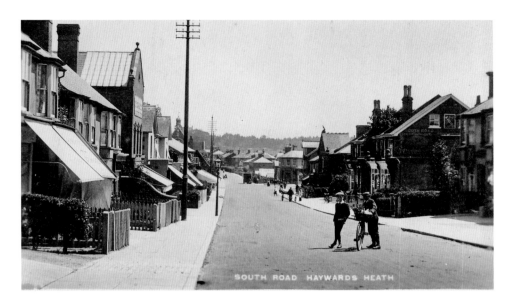

SOUTH ROAD HAYWARDS HEATH

### Haywards Heath, South Road

Situated in West Sussex today, the large commuter town of Haywards Heath, lies 36 miles south of London, 12 miles north of Brighton and 15 miles south of Gatwick Airport. The arrival of the railway from London in 1841 (ten weeks before it reached Brighton) boosted the development of what was then a minor settlement. Hardly any of the buildings above in South Road have survived. Exceptions on the left are the nearest double-fronted premises, trading today as JoJo Maman Bébé (Nos 54–56), and the tall gabled building (No. 42), which was once the South Road Studios. Here, Harold Tullett, who had previously combined a photography and grocery business in Three Bridges, ran his successful photography, picture-frame making and postcard publishing business from about 1902 until his retirement in the early 1920s, when he sold out to George Banbury, who traded as a photographer there until the late 1930s.

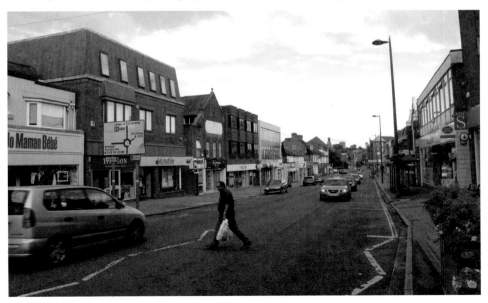

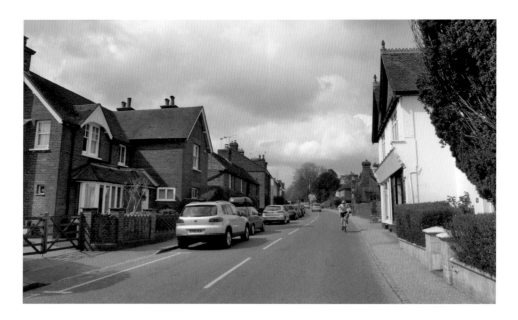

### Ardingly, High Street

This cyclist enjoys the freedom of the B2028 road as he passes the Peking Chef takeaway and its vacant adjoining shop. From 1829 to 1949, the family business of Sayers & Son ran both premises, selling grocery and ironmongery from the north premises and clothing from the south. Below, the horse and cart appear to be facing the pair of mid-nineteenth-century cottages named Latches and Holland Cottage (Nos 21 and 23), originally Nos 1 and 2 Holland Cottages built in 1875; the substantial ivy-clad residence is the Red House (No. 19) of 1886. Situated about 3½ miles north of Haywards Heath and 6½ miles south-east of Crawley, Ardingly was in 1997 awarded the title of Best Kept Large Village in Sussex. It is famed for Ardingly College at the southern edge of the village, for the South of England Showground and for Wakehurst Place, described as one of the most beautiful gardens in England.

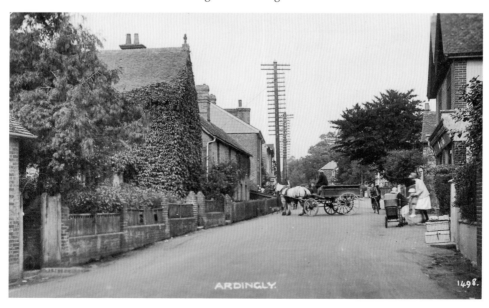

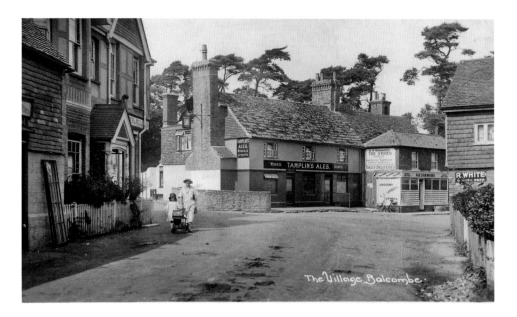

## Balcombe, Haywards Heath Road

The Half Moon Inn stands in the background of both views here and has changed little, save for the loss of its outside chimney. Adjacent to it is The Stores, run at the time of this 1920s postcard by one G. E. Simmons and still thriving. Beyond it, a lane leads to Balcombe House, built in around 1760 as a rectory. On the extreme left above can be seen part of a butcher's sign in the property known as Burts, a late fifteenth- or early sixteenth-century building, and next door, where the mother and child are, stands Alexandra House, dating from 1902. The former millinery business has become a haberdasher's/dry cleaner's/florist's. Balcombe, 6 miles north-west of Haywards Heath and 16 miles north from Brighton, is attractively situated and is served by the London–Brighton line. The tunnel and viaduct that bear its name are major local features of the railway.

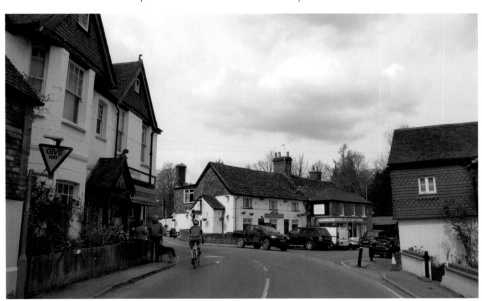

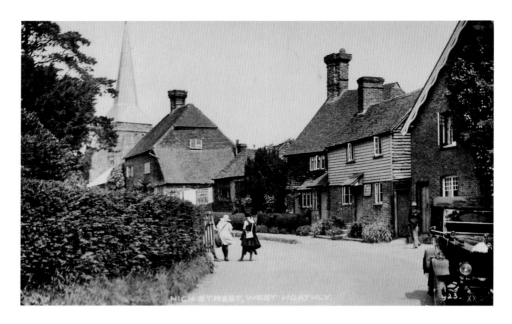

### West Hoathly, North Lane

West Hoathly, 3½ miles south-west of East Grinstead, has Saxon roots and a Norman church, although only a remnant remains. During the fifteenth, sixteenth and seventeenth centuries, the iron industry dominated the parish. Behind the 1924 Bullnosed Morris Cowley car in the anonymously published postcard above stand Lower Pendant and, in succession, Phlox Cottage and Rose Cottage. Beside the latter is an undertaker's shed, later converted to a school, but this no longer exists. The large residence with the tower of St Margaret's church behind it is Upper Pendent (*sic*), which once incorporated a shop. This replaced a corrugated iron post office and grocer's store adjoining it to the north known locally as the 'tin shop', which was demolished in 1956. For a time, however, both shops operated concurrently. From 1975 to 1990, the Upper Pendent shop sold only antiques.

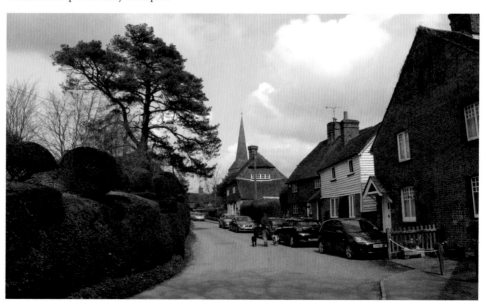

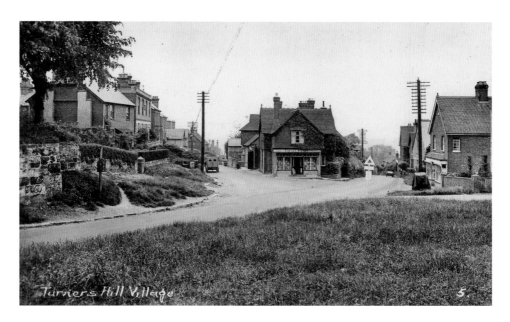

Turners Hill Village

## Turners Hill, The Village Green

A Mecca for cyclists and bikers, Turners Hill stands at the top of a steep ridge line at one of the highest points of the Sussex Weald at the intersection of two historically important routes, the B2110 (Church Road) and B2028 (North Street). It is located 3 miles south-west of East Grinstead and 4 miles south-east of the Crawley New Town area. Unusually, the Village Green is a triangular island yet remains a focus for residents and visitors. Mindfulness of the busy traffic is important. On the right stands the property Sunnyside (1897), North Street, clearly a shop in the early view but now purely residential. Castle's Stores, in the centre of the picture, continues as the village shop in the form of the Central Stores. In Lion Lane (left) are Providence Terrace (1901), now accommodating two shops, and other more historical buildings.

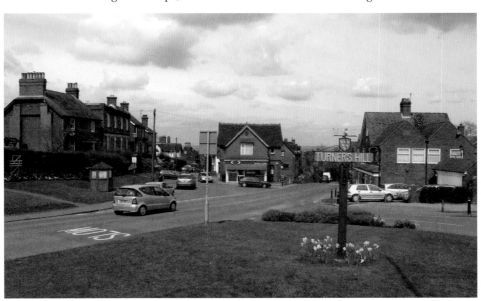

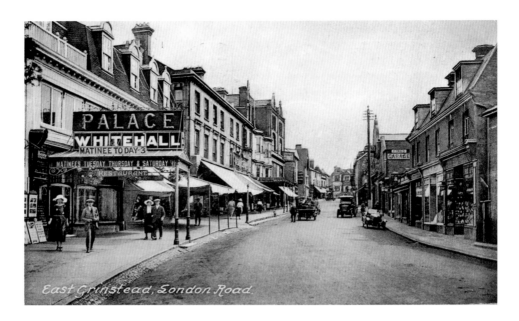

### East Grinstead, London Road

Historical East Grinstead is located in the north-eastern corner of the Mid-Sussex District and boasts a population of approximately 29,000 today – more than triple the 1891 figure. The Whitehall cinema, seen above in a 1921 postcard, was part of a redevelopment of the Grosvenor Hall and Restaurant of 1883 and had opened in 1910 as a theatre. In 1936, today's Whitehall Parade was created with the acquisition of adjoining properties. On 9 July 1943, two bombs fell in the cinema auditorium, resulting in 108 deaths (the largest loss of life of any single air raid in Sussex) and 235 people being injured. About one third of the victims were children. The façade of the destroyed cinema remained intact. For their part, the restaurant and ballroom gave way in later years to more shops, offices and a nightclub.

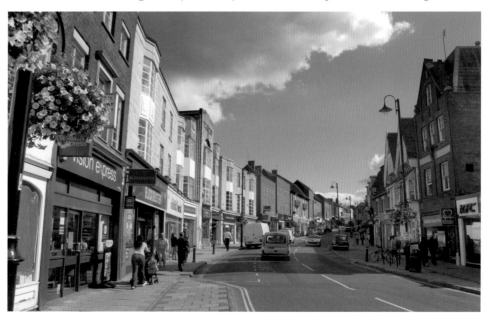

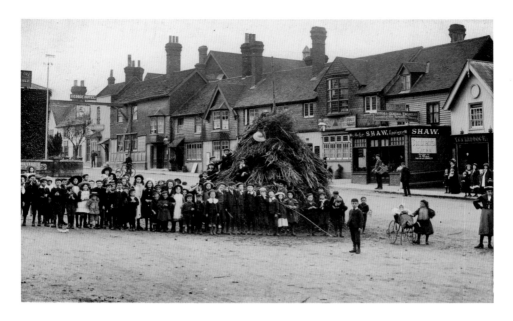

## Crawley, High Street

Due to the precise location from where the splendid photograph above was taken being blocked by the stalls and paraphernalia of market day traders, the same angle could not be used on a recent visit. The occasion is assumed to be preparation for Guy Fawkes' night. In medieval and Tudor times, Crawley was a major centre of iron smelting. Being situated midway between London and Brighton, it was ideally located to become an eighteenth-century coaching town. In the background on the left may be seen the former coaching inn the George Hotel, dating from the sixteenth century, with its gallows sign straddling the road. Now marketed as the Ramada Crawley Gatwick Hotel, it occupies centre-stage in the recent picture. Crawley was designated a New Town in 1947 and its planned centre, Queen's Square, was officially opened in 1958.

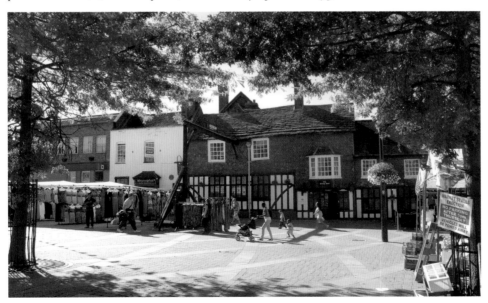

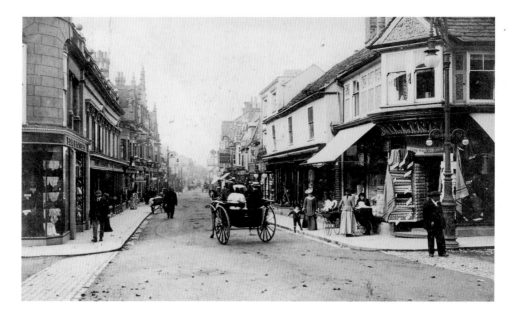

### Horsham, West Street

Pedestrianised in 1992, bustling West Street has, over the years, lost many of its elegant buildings and family businesses, together with a number of their interesting shop signs. On both corners at this eastern end stood drapery stores: Hunt's on the left and Chart & Lawrence on the right (the date of 1898 may just be discerned within the ornate gable). Hunt's, for its part, moved next door to No. 2 when its premises were rebuilt to house the Capital and Counties Bank. Located 31 miles from London and 26 miles from Chichester, the market town of Horsham boasts a history spanning more than a thousand years. Well served by road and rail links, it was in October 2006 judged by a Channel 4 show to be second only to Winchester as the best place to live in the UK.

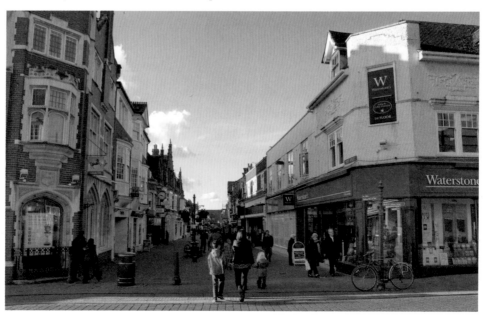

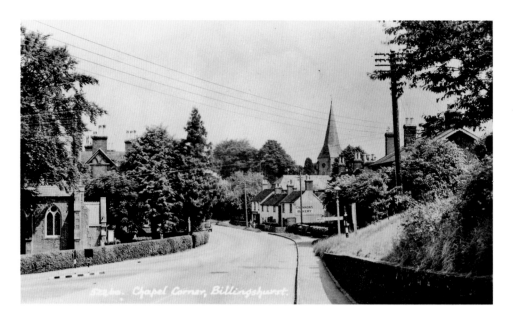

## Billingshurst, Alicks Hill

Prominent in these views of the village, located on the old Roman road from London to Chichester, is the spire of the parish church of St Mary, occupying a commanding position above the Roman Stane Street. The oldest parts of the building can be dated to the second half of the twelfth century. Chapel Corner is so named on account of the partly visible Congregational church on the left, built in 1868; a schoolroom, now used as a hall, was erected adjacent to it in 1885. The church became the Trinity United Reformed church in 1972. Set back behind the High Street is the Unitarian chapel, founded in 1754. It is one of the oldest Nonconformist places of worship in the district of Horsham. Billingshurst lies 7 miles south-west from that town and 9 miles north-east from Petworth.

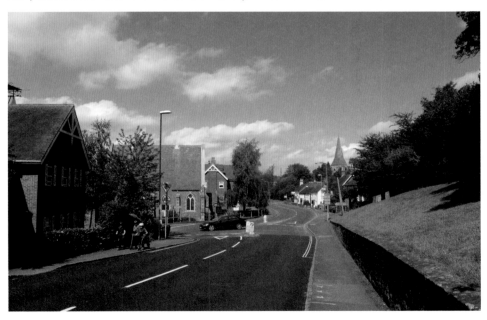

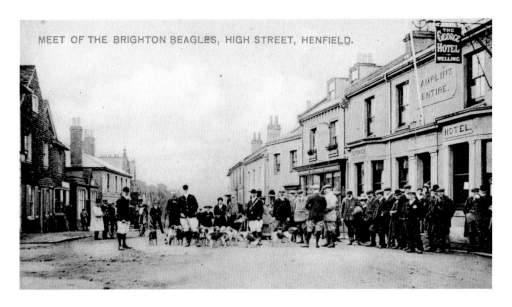

MEET OF THE BRIGHTON BEAGLES, HIGH STREET, HENFIELD.

### Henfield, High Street

The noted countryside writer S. B. P. Mais wrote in his book *Oh! To Be In England* (1922) 'If you feel that you aren't getting enough air, give yourself one whole day with the Brighton beagles ... you will return with such an appetite for dinner that you may surprise even the head waiter'. Here the pack and huntsmen are gathered in front of the George Hotel, a coaching inn built in Tudor times from which, in later times, post chaises and saddle horses could be hired. Henfield, a large village where tanning and brickmaking were once important, is located midway between Horsham and Brighton. Its High Street is part of the old route from London (33 miles distant) to the latter place. The village's railway link, on the Steyning or Adur Valley Line connecting Horsham and Shoreham-by-Sea, was lost in 1966 through the Beeching axe.

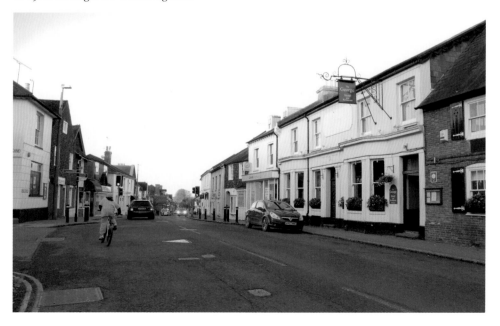

## Bramber, The Street

Before the River Adur silted up and changed its course centuries ago, Bramber had a landing stage or wharf near St Mary's House and one nearer the castle when it was being built for the unloading of stone. The towering gatehouse wall of the castle, whose ruin was caused by subsidence during the sixteenth century, can be seen in the background. The small church of St Nicholas in the distance, still in use today as the parish church, is located directly next to the castle entrance and used to be a chapel for the castle's inhabitants. The three charming historical cottages on the right are named The Old Cottage, Jasmine Cottage and Firs Cottage. Incongruously, the greenery on the extreme right conceals a major development, namely the construction of two pairs of semi-detached properties, following the demolition of the Castle View Rest Home.

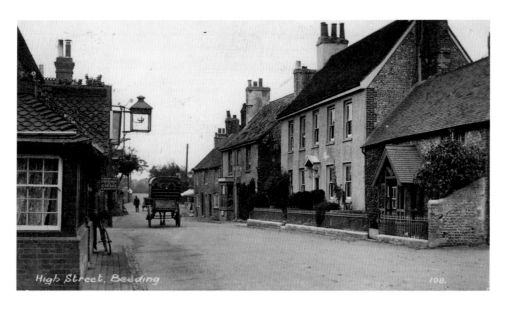

### Upper Beeding, High Street

Leaving Bramber and heading south-east, one comes almost imperceptibly (save for the hump bridge over the River Adur) to ancient Upper Beeding, known originally, and locally, simply as Beeding (Lower Beeding, for its part, is located some 10 miles distant near Horsham). The stuccoed King's Head public house on the left dates from the fifteenth century. On the right, Manor Cottage, whose gabled porch has given way to a continuous tiled hood, was built in the mid-1600s. The substantial eighteenth-century (or earlier) building next door has undergone even greater change: the property has been divided into The Manor House (nearest) and The Farmer's House, at one stage a pharmacy, to which two bay windows have been added. The light blue house, today's Khushbu Tandoori, was once the post office.

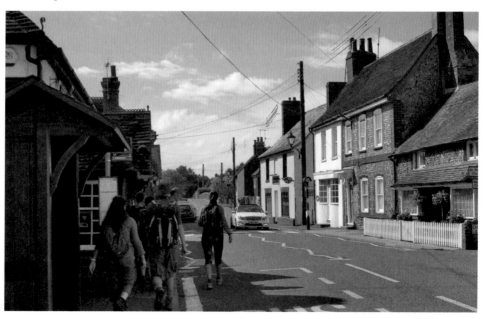

### Steyning, High Street

The small town of Steyning, with part of its High Street pictured here, is located some 6 miles north-west of Shoreham-by-Sea and the same distance north-east of Worthing. One of the prettiest Sussex towns, it has a long history, dating back to at least the eighth century. In the early Middle Ages, it was a thriving port until the River Adur silted up. Although the entire main road is known today as the High Street, over a century ago the name applied only to the section from Church Street to the Horsham Road. The lower part was for centuries known as Singwell Street. Below, the Revd Arthur Congreve-Pridgeon (Vicar from 1882 to 1918) is talking to Colonel Young. Over the road, two free-roaming cattle are looking warily across at the butcher's shop run by Felix James Cherryman.

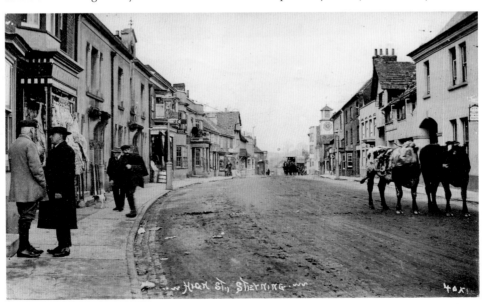

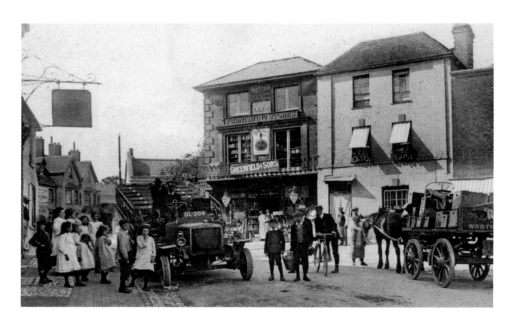

### Storrington, The Square

This splendid animated postcard was published no earlier than 1907 by J. Greenfield & Sons but doubtless printed by the Mezzotint Company of Brighton, whose hallmarks it bears. Greenfields had a strong trading presence in the village from 1864. Here the family Furnishing Stores (now named Greenfield House) overlooks the Square, with E. J. Greenfield's home conveniently located next door. That property has since doubled in size and both have been refaced. The distinctive charabanc parked outside the White Horse on the extreme left is, by an amazing coincidence, the very one featured in Newhaven High Street (see page 48), namely a Worthing-operated Thornycroft 80 B4 purchased new in 1907. Storrington is bisected by the A283 and lies roughly 5 miles equidistant between Steyning to the east and Pulborough to the west.

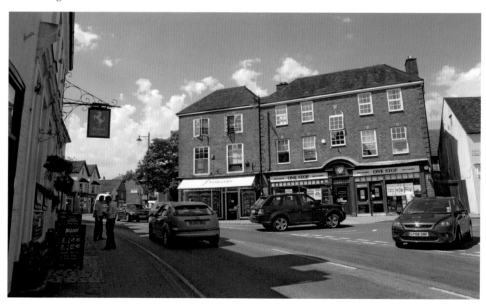

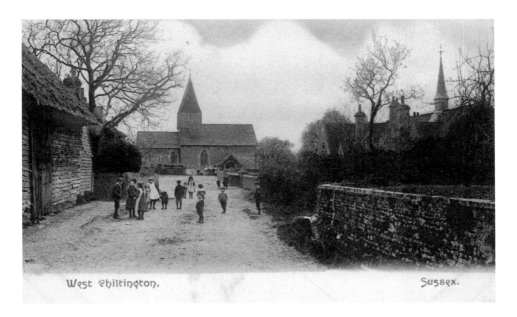

West Chiltington,                                    Sussex.

## West Chiltington, Church Street

In every year from 1996 to 1970 inclusive, West Chiltington, located 12 miles from Horsham to the north-east and the same distance from Worthing to the south-east, won the title of Best Kept Village in West Sussex. A circular plaque by the largely twelfth-century church of St Mary (pictured) informs us that this community was recorded in the Domesday survey of 1086. Church Street, formerly known simply as The Street, contains an interesting mix of early cottages (including the sixteenth-century Hobjohn's Croft) and more modern dwellings, such as those in the cul-de-sac named Wheelwrights, out of sight on the left. On the right, the buildings of the former school, erected in 1876 for pupils aged five to fourteen, are now private dwellings, comprising the Old School House and the Stone House; the latter, which was the headmaster's residence, has lost its spire. The replacement school, today's West Chiltington Community School, opened in March 1975.

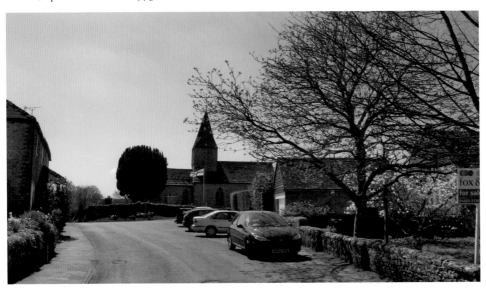

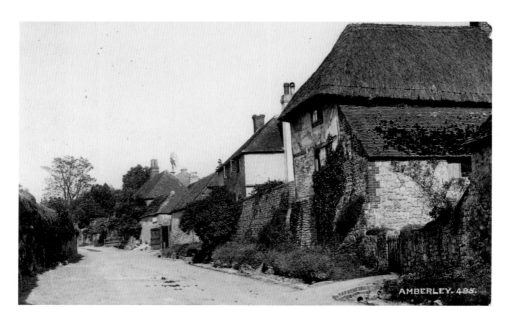

## Amberley, East Street

Described on the West Sussex Information website as 'one of the most attractive of all downland villages', which has 'practically everything', Amberley, at the foot of the South Downs, is full of charming thatched dwellings, a fine example of which is Old Cottage on the right, a seventeenth-century or earlier timber-framed cottage on two storeys with a hipped roof and casement windows. Two skylights have been added to the tiled roof area. The yard behind the gate formerly contained a piggery and cattle byre, but the land is now developed, with a substantial detached house dating from 1985/86 occupying part of it. Yet the village is no rural backwater: it has its own railway station on the Arun Valley Line, with regular services to Bognor Regis, Portsmouth and London. Its castle is now a popular hotel and its Museum and Heritage Centre attracts large numbers of visitors.

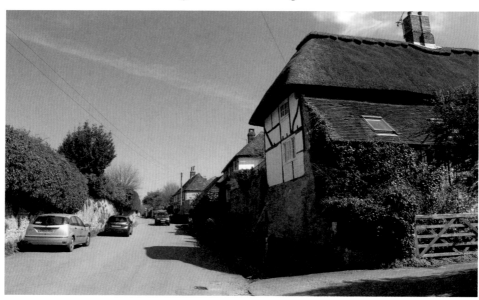

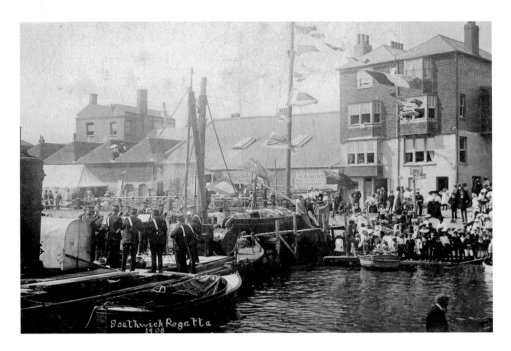

Southwick Regatta
1908

### Southwick, River Adur

We enter the Adur District of West Sussex via Southwick, a small town and civil parish located 3 miles west of Brighton. Skirting Brighton Road are the harbour and its businesses, among them the Sussex Yacht Club, which has since 1926 occupied the buildings with hipped roofs, and can be seen in both pictures. The Schooner Inn on the right dates back to the early 1800s, when it was built over an existing morgue. The large barn-like building in the animated 1908 Regatta picture above was the Old Malt House's coal store, whose site is now occupied by two recently-constructed dwellings.

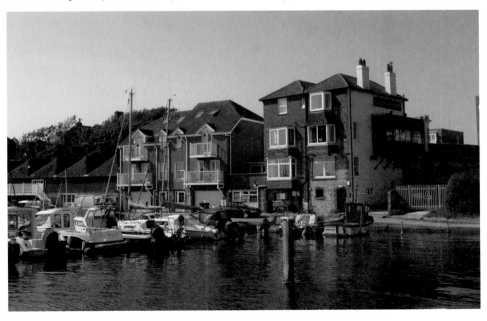

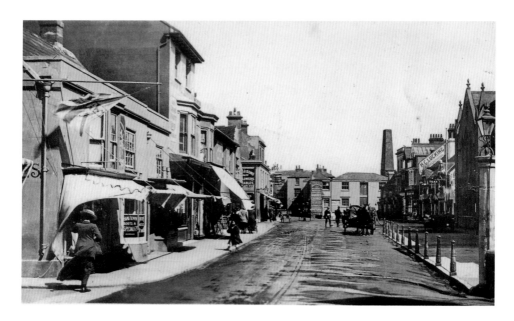

### Shoreham-by-Sea, High Street

The High Street of this coastal town between Hove and Worthing as it appeared a century ago is interestingly depicted in the above postcard published by W. H. Smith & Son in their 'Kingsway' series. We are looking eastwards, with the River Adur out of sight on our right and the south end of John Street on our immediate left. The most dramatic change is the disappearance of the Albion Brewery (behind the horse and cart) and adjacent chimney. Coronation Green near the footbridge currently being replaced, now occupies the site. The distant building in shadow was the west end of Dolphin Chambers, formerly the Dolphin Inn, demolished during road widening in 1938. On the right, the chapel, erected on the site of the first Royal George Inn, no longer stands; nearby Lucking's only ceased trading in 2011 from its base in East Street.

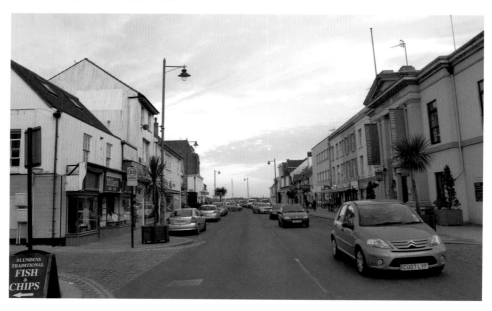

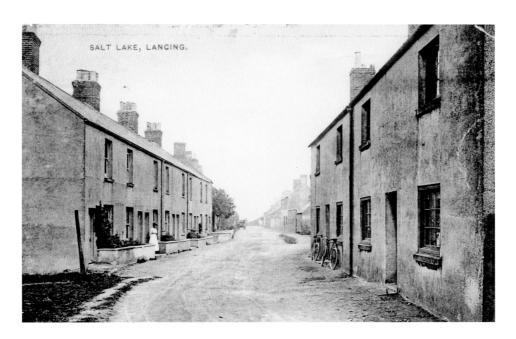

### Lancing, Salt Lake Cottages

Located between Shoreham-by-Sea and Worthing, the heavily residential community of Lancing was once a minor resort and, with its extensive railway carriage works (1912–64), a centre of industry. Market gardening was carried on here from as far back as around 1840 and was described as the chief industry in the late 1920s. Salt Lake Cottages date from the 1830s and were associated with that activity. Those on the right in the early view have been replaced by modern housing but those on the left have survived as Nos 3–25 Freshbrook Road. They stand close to the railway line, which opened through the parish from Shoreham to Worthing in 1845.

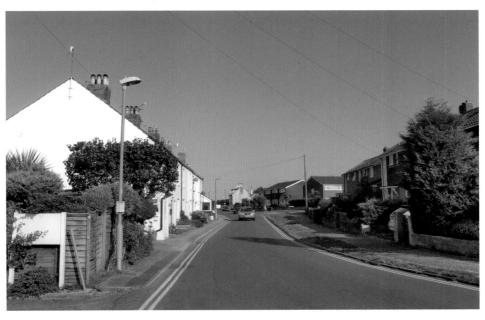

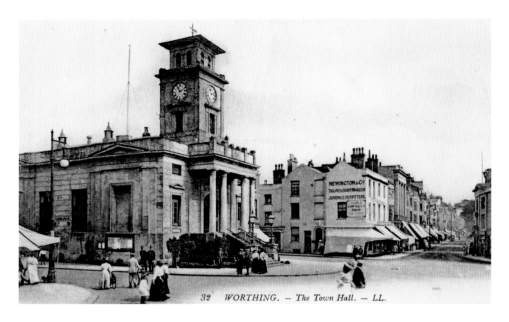

32 *WORTHING. — The Town Hall. — LL.*

### Worthing, South Street

The large town and resort of Worthing (population 102,000), located 10 miles west of Brighton and 18 miles east of the county town of Chichester, attracted fashionable visitors in the early nineteenth century, when it saw a period of rapid growth. The railway arrived in 1845. Eleven years earlier, this fine classical Town Hall was built to the design of the town surveyor Ralph Jones on a plot of land called Wealdens, sold to the Town Commissioners by Sir Timothy Shelley. It opened in 1835 and was used until the opening of the new Town Hall in 1933, from which year it was referred to as the Old Town Hall. It was, sadly, demolished in 1968. In 1974, the Guildbourne Centre, a shopping mall, was built on its site and that of a number of the older narrow streets around it.

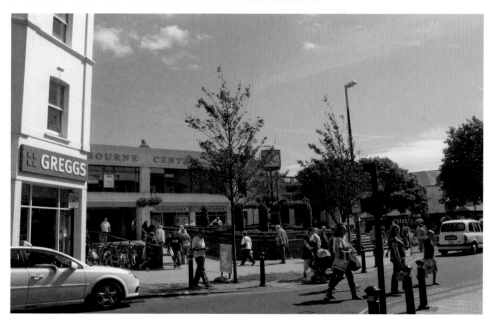

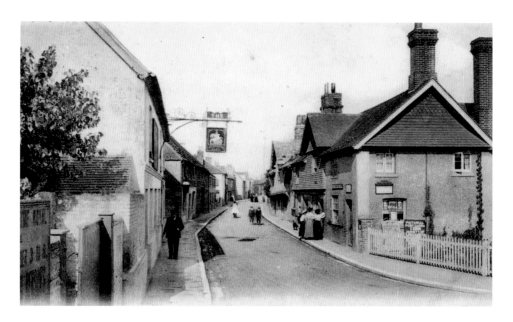

## Tarring, High Street

The earliest mention of this charming village – officially called West Tarring or, less commonly, Tarring Peverell to differentiate it from Tarring Neville north of Newhaven – dates from the year 941. Its parish church of St Andrew is of pre-Conquest origin. The community, now incorporated into the modern town of Worthing, boasts a number of interesting old buildings, including the seventeenth-century George and Dragon (originally The White Horse) on the left, and especially the timber-framed Parsonage Row Cottages dating back to 1470 on the right. The cottage at the southern end was unfortunately demolished in 1895 when the road was widened. Those remaining, numbered 6, 8 and 10, were bought by the Sussex Archaeological Trust in 1927 and converted in 1963 into a Museum of Sussex Folklore, complete with a custodian's flat. In 1987, the Grade II* buildings were combined into a restaurant, still trading, aptly named The Parsonage.

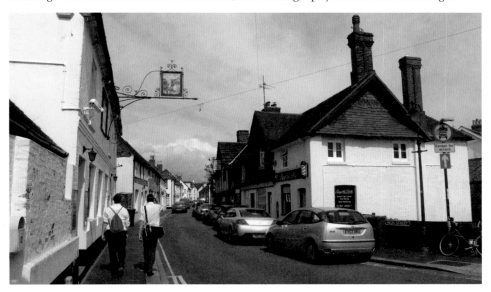

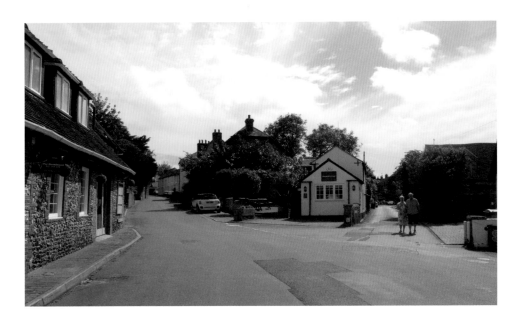

### Findon, Nepcote Lane

The placid village of Findon, stituated 4 miles north of Worthing, has had the benefit of being bypassed by the A24 since 1938. It boasts no fewer than five public houses, four of which are located in the High Street. While substantially similar, these two views illustrate the profound social and commercial change that has taken place over the last century. Today, the Steakhouse Bar and Grill has supplanted the old smithy, established in 1760. There were once three forges in the village, run respectively by a Mr White, a Mr Green and a Mr Brown. The early (pre-1913) postcard shows Ernest Walter Brown in the doorway of his shop next to the smithy, as he had branched out into bicycle-making. He designed his own machine in the 1930s which he aptly named the 'Findonian'. Today, the premises, until recently a convenience store, lie vacant.

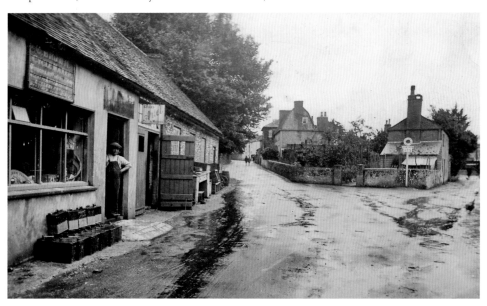

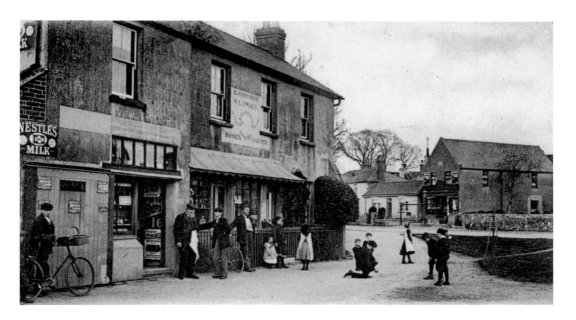

## Angmering, The Square

Pictured here is Blaber House, built in the early 1880s by William Langley who ran it as a grocery, stationery and (oddly) hosiery business until 1913, when his son, Alfred, took over. When the First World War ended, grocer Walter Cheesman acquired the business and managed it for fifty-three years. Run as an antique shop for some years, the building has since 2007 been used by a dental practice, which has let part of the premises as a flat. The Green, now poignantly the site of a war memorial, was so prone to flooding in the past that a flat-bottomed boat was kept to hand as a ferry! Long since replaced are the businesses in the background, namely Dench's general store (right) and the premises of Peskett & Son, engineers and ironmongers. Angmering is roughly equidistant (4 miles respectively) from Worthing to the east and Littlehampton to the west.

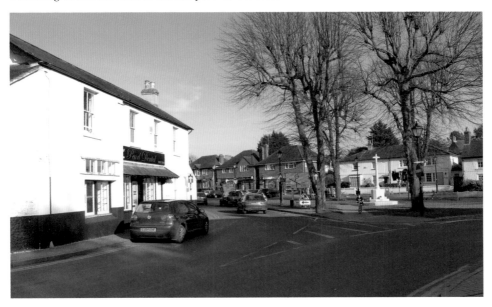

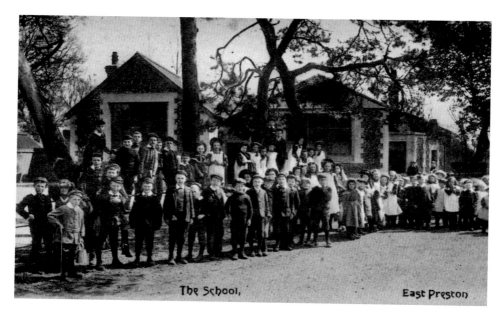

The School,      East Preston

**East Preston, Sea Road**

The village of East Preston lies roughly halfway between Littlehampton and Worthing. Its school, depicted here between 1902 and about 1906, had grown from a Sunday school built in 1840 through a charity established by landowner George Olliver. He had received a large reward for reporting a farm labourer (Edmund Bushby) for igniting a hayrick in protest against farm machinery replacing manual labour. Bushby was subsequently hanged. The school was extended piecemeal – in 1871, 1883, 1889 (when a playground was provided) and 1898 (when an infants' room was built). Three years later, Herbert Taylor was appointed head and remained in post until June 1933. Given to Sussex County Council in 1940, the school closed in 1951 when the new establishment in Lashmar Road was opened. Below, two of the author's granddaughters stand beneath the rescued and resited foundation stone.

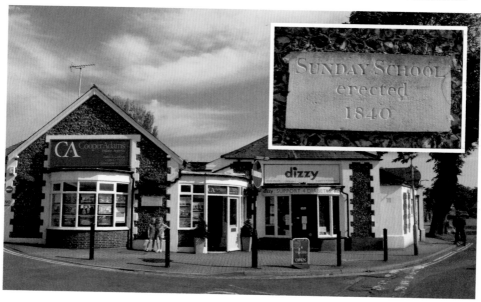

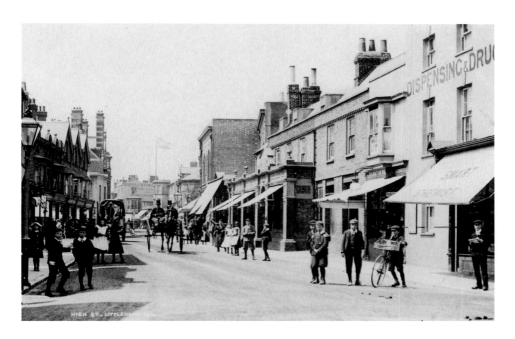

### Littlehampton, High Street

Bustling Littlehampton on the River Arun boasts a long history as a trading and small-scale fishing port. It developed as a bathing resort soon after 1800 and continues to be popular with visitors and tourists. Among the businesses depicted in the animated postcard is Smarts the Chemist, started in 1836 by Neville Smart, chemist, wine merchant, newsagent, tobacconist and vet. It traded until well into the 1980s. Also on the right are the awnings and shopfront of the nineteenth-century Constable Brewery, once the second largest employer in the town. At the far end of the street is a branch of the Supply Store, run at the time by a Peter Ellison. The site (no longer visible from this standpoint) was rebuilt in the 1970s by a superstore called Key Markets and is now occupied by Sainsbury's.

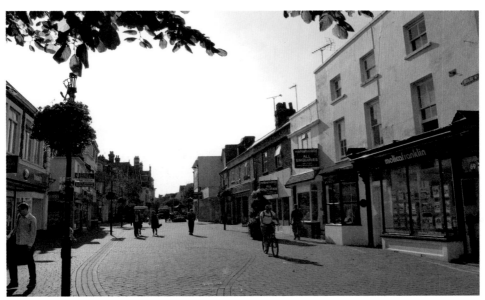

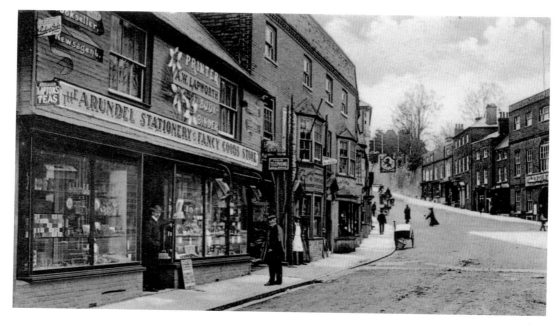

## Arundel, High Street

Noted for its splendid eleventh-century castle, climbing streets, quaint shops and attractive riverside location, the market town of Arundel lies 10 miles east of Chichester and 18 miles west of Brighton. Above we see, at No. 33 High Street, the Arundel Stationary and Fancy Goods Store with no doubt the proprietor – and publisher of the postcard – Alfred Walter Lapworth (1851–1915) standing in the doorway. The premises have been occupied by Pizza Express since 1998. Between No. 33 and No. 37 next door (part of the sixteenth-century Crown Inn) is a passageway leading to the public car park. Prominent across the road is the Norfolk Arms Hotel, built by the Duke of Norfolk between 1782 and 1785.

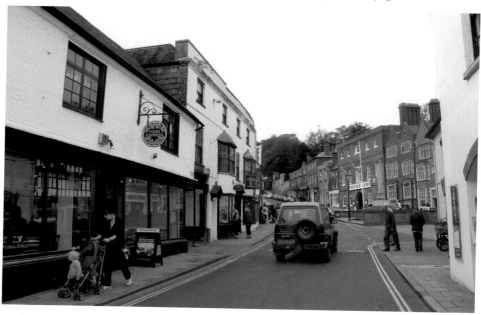

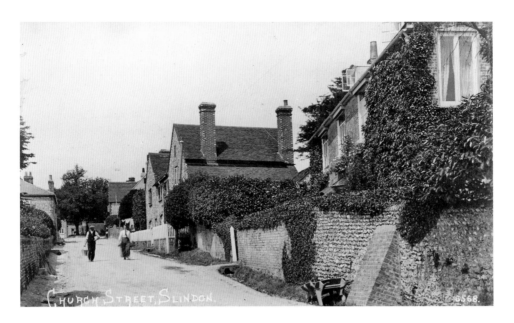

## Slindon, Church Hill (Ex-Street)

This downland village, some 7 miles NE of Chichester, is unusual in that two-thirds of it is owned by the National Trust. The Elizabethan manor house, which is today's independent Slindon College, was bequeathed to the Trust in 1949 by Frederick Wootton Isaacson, together with a substantial endowment. The Trust also owns 750 acres of local woodland and the largest of the farms in the area, Court Hill Farm, covering 986 acres. The Grade II listed Church House on the immediate right was occupied from 1922 to 1970 by the family of the Revd Arthur Izard, village rector from 1896 until his death in 1919; he is remembered for his restoration of the church of St Mary, out of sight on the left. In the grounds of the house is the curiosity of an ex-LBSCR Stroudley railway carriage (thatched!) dating from around 1874.

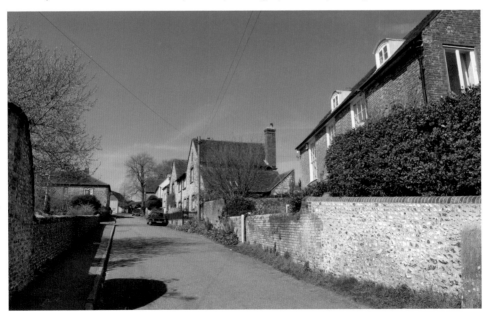

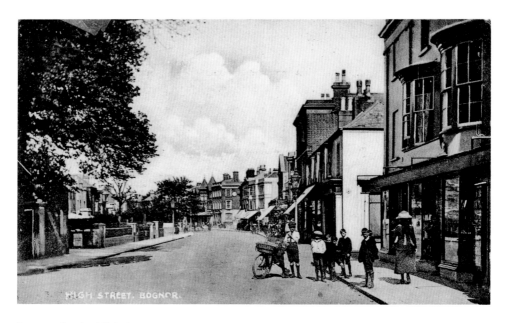

## Bognor Regis, High Street

It is hard to imagine today that the High Street was part of the original lane that ran through the old village to the sea. One noticeable change between the old and modern view here is the disappearance of the villas and gardens on the left side of the street. The once no doubt elegant villa on the right, at the junction with Lennox Street, today stands somewhat forlorn. Between the buildings with conical roofs in the far distance stands the Arcade, linking the High Street and York Road. It was constructed between 1901 and 1902 by local builder William Nathaniel Tate and some of its fine cast-iron columns still stand. Bognor's transformation from a fishing hamlet to a resort – the very first in the country to be specially developed for bathing – started in the late eighteenth century through the impetus of wealthy landowner and MP Sir Richard Hotham.

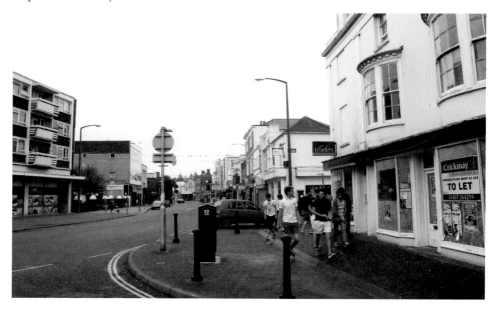

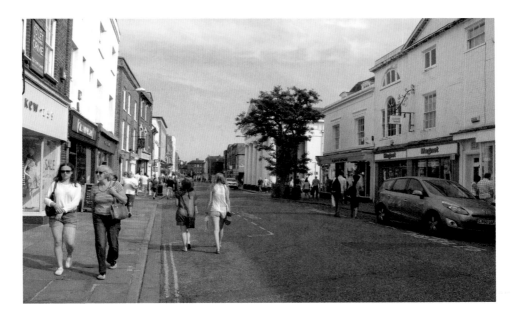

## Chichester, East Street

Of interest in this contemporary view of the ancient county town of Chichester is the elegant Corn Exchange of 1832/33, here partly obscured by a tree. At the beginning of the twentieth century it was turned into a cinema while in recent years it has served as a fast-food outlet and (currently) a branch of a retail clothing chain. Below, East Street is colourfully bedecked for the Coronation, on 22 June 1911, of King George V and Queen Mary. Citizens were invited to decorate their premises and illuminate their houses at night. Following a morning service in the Cathedral, local groups marched in procession up this street and down South Street to Canon Gate. Sports events, a street carnival, a torchlight procession and the lighting of a monster bonfire also contributed towards making this a memorable day for the city.

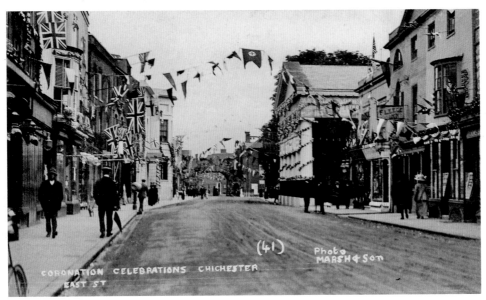

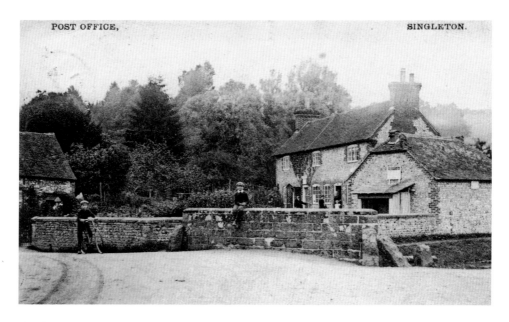

### Singleton, The Old Post Office

'This is a lovely place', wrote the sender of this postcard in September 1910, and that opinion holds true more than 100 years later, even if the A286 connecting Midhurst and Chichester, both about 5 miles distant, does bend quite sharply at this point, necessitating caution by pedestrians. The post office, which in more modern times was also the telephone exchange, was run from 1850 to the 1950s, from the early eighteenth-century two-storey building on the right (in the early view). The outbuilding, which has in the past been used as stabling and a wash house, has been converted to guest accommodation. The shallow clear stream that passes under the bridge rises from a pond in East Dean. It is actually the River Lavant – the river that in 1994 caused extensive flooding in Chichester and surrounding villages.

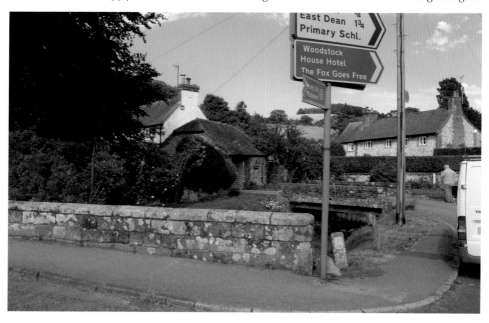

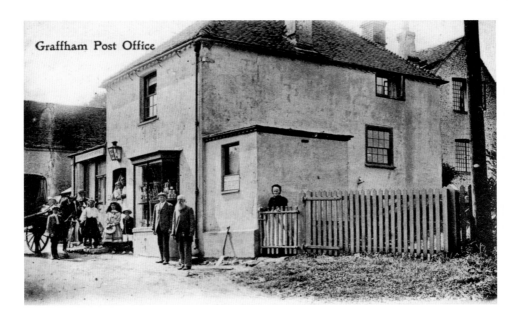

Graffham Post Office

## Graffham, The Street

This view of the village post office dates from the early 1900s, at which time Frederick Pescod was the sub-postmaster. There were two daily deliveries (via Petworth) and two collections; the nearest telegraph office was at the long-closed railway station of Selham, 3 miles distant (Graffham and Selham today constitute a single parish). In 1994, the 'two up and two down' building comprising two seventeenth-century cottages, long known as Pescods, reverted to residential use following its use as a general store. Through the efforts of the Graffham Village Shop Association, a replacement store was established on the then recently redundant village garage site in The Street and opened in December 1994. The successful premises have since been enlarged and have been provided with new residential accommodation above.

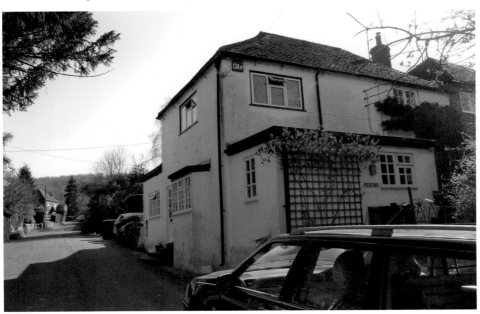

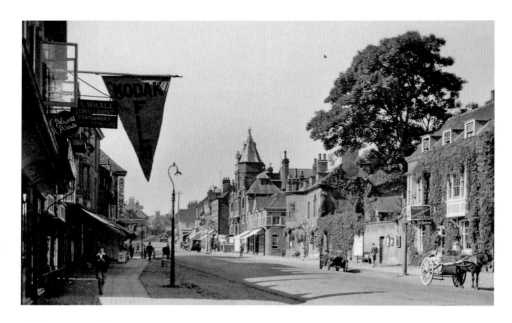

## Midhurst, North Street

Since 1934, when the above Judges postcard was published, a number of major changes have taken place on this main thoroughfare and shopping centre on the A272. Rosemary House, a private residence, has replaced the greenery-clad Rosemary's Parlour Tea Rooms and Guest House, although part of the building, still named Rosemary's Parlour, is used as offices by the South Downs National Park Authority. The distant tower surmounted a building which opened as a public hall in 1882 and subsequently became a cinema. Ultimately named the Orion, it closed in 1962 and was demolished five years later, being replaced by a supermarket (originally the International, today Tesco Express) with flats above. The premises on the left, now part of Stockley Trading, were occupied by tobacconist, stationer and postcard publisher Arthur Edward Whale (1884–1977), a Londoner, whose local views are scarce today.

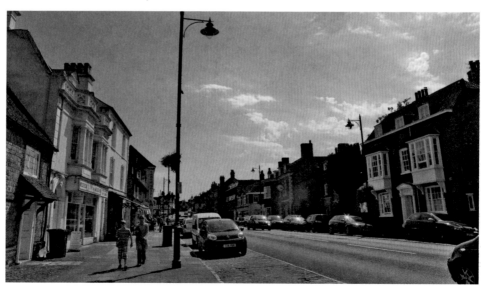

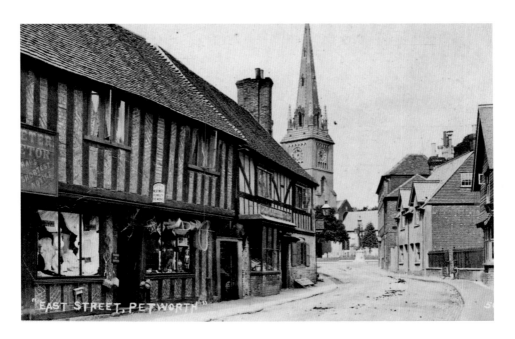

### Petworth, East Street

The most striking difference between our two images here is the disappearance of the spire from the mid-fourteenth-century tower of the church of St Mary the Virgin. It had become unsafe and remedial work was carried out in 1947. The original spire under construction was painted by Turner in 1827. The quaint old buildings in these views have changed little. One window above advertises 'Useful presents', while basketry items hang outside the other. Today an antique shop operates from this seventeenth-century (or earlier) building. Next door (The Covert) was a greengrocer's run by one Edward Webster, certainly in 1899 and 1905 but no longer by 1911. Today the shop, of the same age as its neighbour, sells fly-fishing equipment and musical instruments. Historic Petworth, a town replete with antique shops, lies some 12 miles north-east of Chichester.

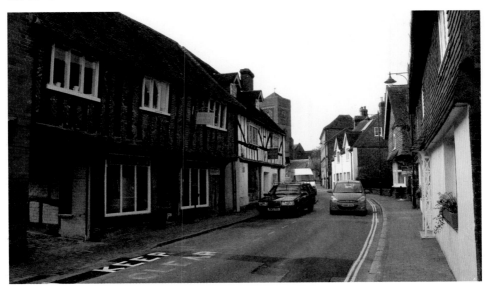

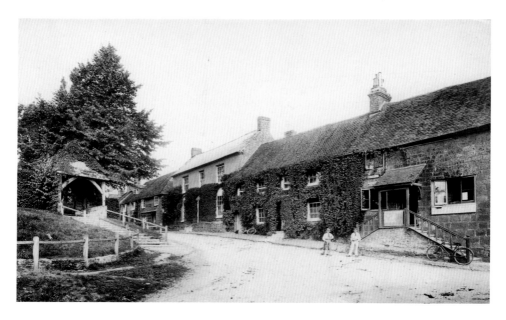

### Pulborough, Church Place

Pulborough, an attractive large village on the River Arun, is located 6 miles south-east of Petworth and 5 miles south-west of Billingshurst. The striking difference between these two photographs of Church Place at its junction with the A29 is the absence of the sixteenth-century dwellings on the right, one of which was being run as a post office at the time of the above early view. In later years, the cobbler's shop and the Chequers Hotel, which occupied the premises were both regrettably gutted by fire in the early hours of 8 November 1963. The hotel's annex, dating from 1548, stands across the road and is today the successful New Chequers Hotel. Tucked behind the vacant space in Church Place is The Chapel, a sixteenth-century building awaiting refurbishment and letting. Prominent in the modern picture are the Grade II listed Church House (right) and Ancaster House (left).

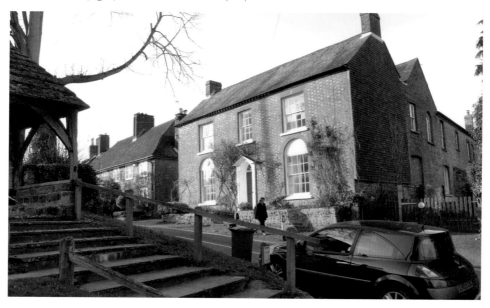

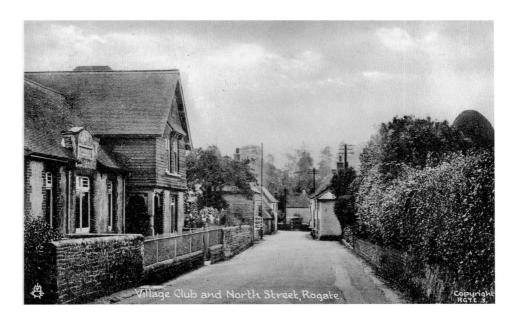

Village Club and North Street, Rogate.

### Rogate, North Street

The premises that serve as the centre for community activities and meetings in Rogate, located 7 miles west of Midhurst and not far from the county boundary, is the modern Village Hall (built 1980–89), whose ample car park stands behind the photographer on the left hand side. The Village Club, erected in 1887 and now named Wynyards Cottage, is today a private residence. The white building on the right, named the White House, dates from around 1750; it was constructed as five dwellings for ironstone workers but in the course of time one at each end was demolished. The remaining three stand today as one residence. The building at the end of the road on the left was formerly the village store, while the distant Grade II listed property across the A272 was previously a public house named the Wyndham Arms; it closed in around 1993.

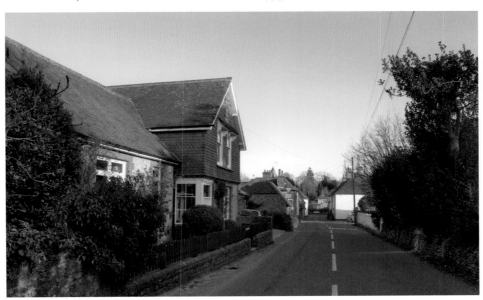

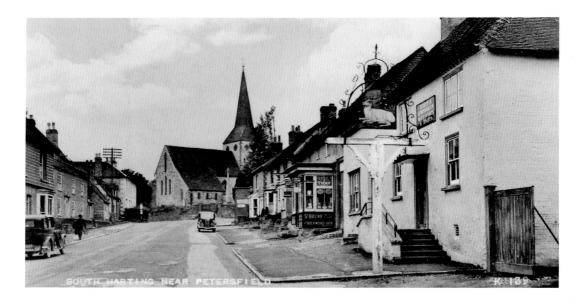

### South Harting, The Street

We end our grand tour of the county on the Hampshire border, just 4 miles south-east of Petersfield. The animated event portrayed here, held on Bank Holiday Monday, 27 May 2013, is the fifty-fourth of the annual festivities celebrated since 1880 by Harting Old Club, the village Friendly Society. On our right stands the sixteenth-century White Hart Inn, which acquired its name in 1904, having previously been called the John Blackmore public house. Next door, the former shop premises – now residential – stand on the site of another inn, The Bucke of around 1480, commemorated today in the house name 'ffowler's Bucke'. The dwellings across the road, numbered 1 to 8, plus Ivy House, include several residences of Tudor origin. Central in the background is the attractive church of St Mary and St Gabriel, which dates mainly from the fourteenth century, although the nave walls may predate the Conquest. (*Upper photograph courtesy of John Owen Smith*)

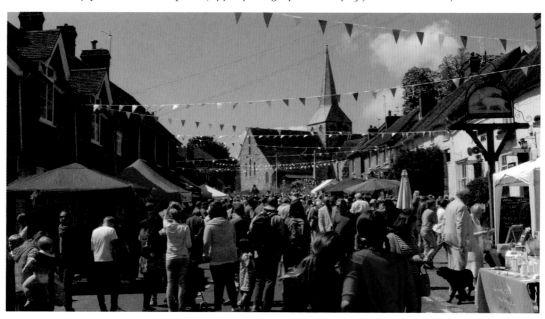

# Index of Places

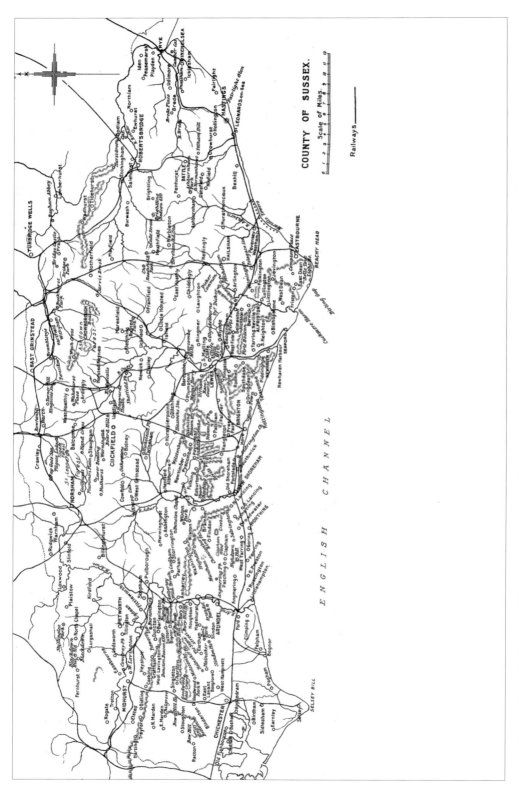

Map of Sussex from Highways and Byways in East Sussex by E. V. Lucas (1904).